DRAW AND COLOR

the Baylee Jae way

DRAW AND COLOR
the Baylee Jae way

CHARACTERS, CLOTHES & SETTINGS STEP BY STEP

BAYLEE JAE

IMPACT
CINCINNATI, OHIO
impact-books.com

Contents

WHAT YOU NEED

PAPER
cardstock
watercolor or mixed-media paper

SKETCHING TOOLS
colored pencils
eraser
HB pencils
ruler

INKING & COLORING TOOLS
brush markers
colorless blender marker
Copic markers
fine-line pens (black, blue and yellow)
paintbrush
watercolor paints
white gel pen

OTHER
acrylic and gouache paints (optional)
craft knife
masking film
masking fluid
scissors

Introduction

How-to-draw books have always been some of my favorite books to own. It's fascinating to see how other artists work and to break down their process, step by step. Each artist is different, which is what makes collecting these books so much fun. We all have different methods and different information to share, so don't look at this book as the one and only way to draw and color.

Also keep in mind that there are very few hard rules in art. Personally, I like to say there are no rules at all, and you're free to experiment and see what techniques work for you. Exploring and discovering is half the fun, so don't feel constrained by rules and conventions. This book is simply a collection of tips and tricks I've picked up throughout my years of drawing. My hope is that you'll find it useful and inspiring.

Tools & Supplies

The most common questions I get are about the art supplies I use. Everyone wants to know what the best markers are, what inking pens work best, or what paints are most suitable for beginners. The answer is not so simple. Everyone has their own preferences, so the tools I like might not be what you prefer to work with.

You will also need to consider the cost of these materials, since top-quality supplies can be extremely expensive. I recommend buying something you can easily afford at your local art supply store. Don't feel pressured to splurge on the most expensive supplies because you might not like that medium as much as you anticipated. Play around with cheaper materials and upgrade once you know what you like.

Many people think that using expensive art supplies will suddenly make their art better. Although good-quality materials can be nice to use, they won't make you a better artist. It's up to you to learn how to use the tools you have. If you're feeling overwhelmed, just remember that all you really need to get started is a pencil, an eraser and a piece of paper.

Sketching Tools

When it comes to sketching, it's hard to go wrong. As long as you're getting your ideas down on paper, it doesn't really matter what tools you're drawing with. You can even use what you already have lying around the house.

PENCIL SHARPENERS

A good sharpener can prevent your lead from breaking too often, but almost any sharpener will get the job done. If you don't have a garbage can nearby, you should use a sharpener that has a receptacle to catch the shavings.

GRAPHITE AND COLORED PENCILS

A regular wooden graphite pencil is all you need, but some people prefer mechanical pencils, especially for fine details. Harder lead is lighter and easier to erase, while softer lead is darker and more difficult to erase. I usually stick with a basic HB pencil. Colored pencils are also an option if you'd like to add a pop of color to your sketches. Keep in mind, they don't erase as easily as graphite pencils.

ERASERS

White erasers usually work better than pink erasers. The skinny erasers that look like mechanical pencils are great for erasing smaller areas. Kneaded erasers can be molded to the size and shape you need.

Inking Tools

Inking tools require some thought. Different tools make different kinds of lines, and the ink you use may or may not smudge when you color on top of it. If you're using a water-based medium like watercolors, you need a waterproof ink. If you're using an alcohol-based medium like markers, you need an alcohol-proof ink. This usually isn't specified on the packaging, so you'll need to do some research, or learn by testing it out yourself. Try playing around with colors other than black to give your art a different look.

FINE-LINE PENS

Fine-line pens are my favorite inking tool. They're easy to handle and come in a variety of sizes. My go-to size is 0.3, but I also use 0.1 and 0.5.

BRUSH PENS

You can create varying line widths with a single brush pen. The harder you press, the thicker the line will be. However, they are a bit harder to control because of the length and flexibility of the nib. Some nibs are made with actual brush hairs while others are felt-tipped, and some brush pens have firmer nibs than others.

DIP PEN OR BRUSH WITH INK

Bottled ink can be used with a paint-brush or dip pen. Some brushes are made specifically for this. Dip-pen nibs come in a variety of sizes and are usually purchased separately from the nib holder. You have to dip the pen or brush repeatedly while inking since there is no ink reservoir inside the tools.

BALLPOINT PENS

Although ballpoint pens are usually looked down upon, they can actually create very interesting art. The ink is reflective and not pure black, but the pens are still fun to play around with. You can even use them for sketching and shading.

Markers

Markers are a fun way to add color to your art without getting messy. They can be layered and blended for professional coloring results. You'll need to opt for an alcohol-based brand because water-based markers don't layer nicely and will chew up your paper. The downside is that alcohol-based markers can be pretty expensive and the ink is not lightfast, which means it will fade over time.

COPIC MARKERS

Copic markers are the most popular and well-known alcohol-based markers. Their quality is excellent, and they're available in hundreds of colors. I recommend getting either Copic Ciao or Copic Sketch markers because their brush nibs are the best for layering and blending. They're also refillable, which saves money because you can replace just the ink cartridge when it runs out rather than buying a whole new marker. Their nibs are replaceable in the event they get damaged or worn. The Ciao markers cost a bit less, but they hold less ink than the Sketch markers and color choice is more limited. Copic markers can be purchased in sets or individually.

OTHER MARKERS

Many other brands of markers cost less than Copics. This saves you money up front, but can end up being more expensive in the long term. Most other brands are not refillable, so when a marker runs out of ink, you have to buy a new one. That can really add up over time. However, if you're just starting out and you're not sure yet if you'll like using markers, a cheaper brand can be a great stepping-stone. Winsor & Newton BrushMarkers, Prismacolor Premier brush markers, Spectrum Noir markers and Blick Studio brush markers are all good brands. The Spectrum Noir markers don't come with brush nibs, but they're very affordable. You can buy brush nibs separately, but they are quite expensive. Other than Copic, my favorite brands of brush markers are Blick Studio and Winsor & Newton.

Colored Pencils

Colored pencils are an easy way to get into coloring. They are great for layering, and color can be built up slowly for easy blending. Top-quality pencils are quite expensive, but cheaper brands are a good, affordable starting point. At the bare minimum, avoid student-grade colored pencils. They have extremely low amounts of pigment, which is not good to work with. Aim for scholastic-grade pencils if possible. Eventually you can upgrade to artist-grade pencils for maximum blendability and colors that are less prone to fading.

TYPES OF COLORED PENCILS AND BLENDABILITY

Some pencils have softer lead, and others are harder. Some are oil-based, and others use wax. Do some research and experiment to find out what type of colored pencils you'll like using best.

Regular colored pencils can be blended by gradually layering colors together. Using a white pencil to blend is a common trick, but you should do that only if blending light colors. White pencil alters the look of the colors beneath it, making them look less vibrant. Instead, use a colorless blender or the same colors you already used. You can also use a solvent, such as an odorless paint thinner, along with a paintbrush to smooth out colors and create a paint-like effect.

Watercolor pencils can be smoothed out by adding water. They're a great way to achieve the look of watercolor paints with the precision of pencils.

Tip

Make sure you don't drop your pencils! The lead can break inside the wood, which makes them harder to sharpen in addition to wasting lead.

Watercolors

Watercolor paints are quite popular with beginners and experienced artists alike. Watercolors are transparent, allowing for a lot of creative blending effects. The paint can even be lifted after drying, so mistakes are easily fixed. As with most paints, the expensive brands are better quality and have higher levels of pigment. Mixing colors is easy with watercolors, however, so you don't need to purchase tons of colors—especially if you're just starting out. That makes it more affordable if you're looking to invest in good-quality brands.

TUBES VS. PANS

Watercolors come in two formats: tubes and pans. Pans are small square cakes of concentrated dry paint, while tubes are larger and contain wet paint. Tubes make it easier to cover large areas since you can squeeze out a lot of paint at once. Pans are compact and convenient for travel or small workspaces. Many companies use the same formula for both, so results should be the same. You can even buy tubes and let the paint dry in your palette, which makes the experience more like using pans. It's all up to your personal preference.

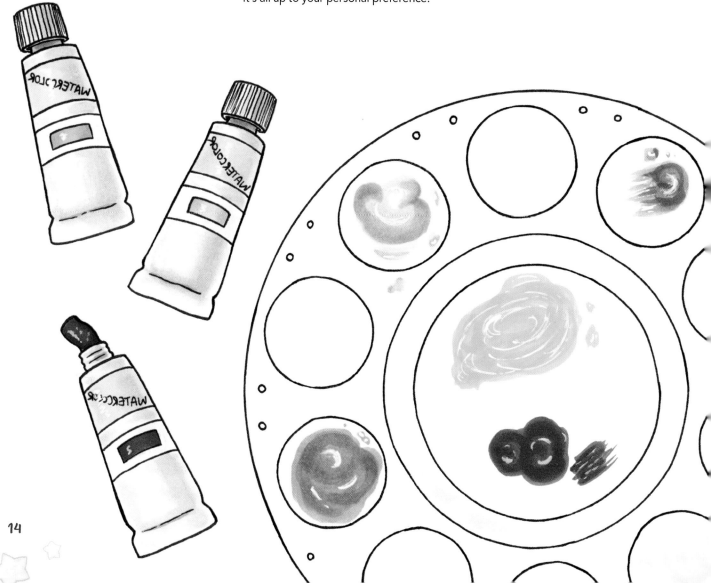

More Paints & Brushes

These paints are less commonly used for the type of illustration covered in this book, but they're still an option. Each type has its own benefits and drawbacks.

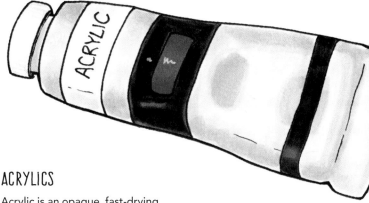

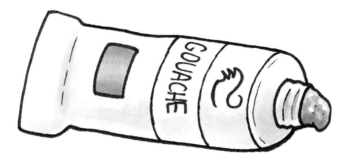

ACRYLICS

Acrylic is an opaque, fast-drying paint that is relatively easy to work with. It can be thinned out using water or acrylic mediums. Avoid using too much water, or the paint can crack or peel. It's recommended your mixture be no more than 50 percent water. Once the paint dries, it cannot be re-wet, so you must work quickly if you want a lot of blending.

GOUACHE

Gouache is similar to watercolor, but it's opaque. It can be used straight out of the tube or diluted with water. If it's diluted enough, it behaves similar to watercolor. If it's not diluted, colors are vibrant but can be difficult to blend. Gouache can be re-wet after it has dried, so less paint is wasted and mistakes are easy to fix.

OILS

Oil paints are smooth and creamy. They dry very slowly, allowing for a lot of blending. The slow drying time becomes a setback when waiting for layers to dry. Once dry, the paint cannot be re-wet. Oil paints must be used with solvents, which are often toxic, so your room must be well ventilated. An alternative is water-mixable oils, which don't require a solvent.

BRUSHES

Each type of paint requires its own brush type. In stores, brushes are normally sorted by medium type—watercolor, acrylics and oils. If you don't know what type of brushes you have, it doesn't really matter. As long as you're controlling the paint the way you want, you're using the right brush.

Paper

Paper is often overlooked by beginner artists. When sketching, any old piece of paper will do, whether it's in a sketchbook or simply a piece of printer paper. If you plan on coloring, you need to upgrade to better paper. Coloring on cheap paper is like buying expensive gourmet food and eating it off the ground because you're too cheap to buy a plate. Don't waste your good supplies on bad paper—they deserve better than that!

CARDSTOCK

Cardstock is my go-to paper when using markers. It's ultra smooth, and colors look vibrant. I recommend using 80–100-lb. (170–210gsm) cover paper if you plan on layering and blending. Cardstock is inexpensive compared to other art papers. However, it's not good for mixed-media art because it's too smooth for layering colored pencil and not absorbent enough for watercolor.

BRISTOL BOARD

Smooth bristol is thick and durable, and can handle a lot of mediums. Markers aren't as vibrant as on cardstock, and they're a bit tougher to blend, but bristol is a good all-around paper for multiple mediums.

MIXED-MEDIA PAPER

Mixed-media paper is also thick and durable. As the name states, it's meant for a variety of mediums. Markers blend really well on this paper but don't look as vibrant as on cardstock. It generally handles watercolor better than bristol board. It also has more texture than smooth bristol, which is good for layering colored pencil.

WATERCOLOR PAPER

This paper works best for watercolors and colored pencils due to its texture and absorbency. The texture and amount of tooth, or roughness, varies by paper type and brand. Avoid using too much marker on this paper since it easily soaks up a lot of ink.

Other Supplies

Here are a few other things you might need as you're following the lessons in this book.

SCRAP PAPER

Scrap paper can be used to make sure ink is flowing, to test out what colors look like together, to learn whether they blend well together, etc. I always have some lying around.

LIGHTBOX

A lightbox is a flat surface with a light underneath that allows you to trace your art. It's handy for creating clean line art without having to ink directly onto your sketch. You can make your own lightbox if you don't want to purchase one.

WHITE GEL PEN

A white gel pen is extremely useful for fixing mistakes and adding highlights. It can also be used for adding details like polka dots or stripes to clothing, or for creating stars in the sky.

MASKING FLUID AND MASKING FILM

Masking fluid and masking film (also known as frisket) can be used to protect areas of your paper where you don't want color. Masking fluid must be applied with a brush. Masking film comes in sheets that must be cut out with a craft knife.

RUBBING ALCOHOL

Rubbing alcohol can create interesting textures when used with alcohol-based markers. It's equivalent to using a colorless blender solution. It can be applied with a cotton swab, paintbrush or eye-dropper.

RULERS

Rulers are extremely handy for drawing straight lines, such as for buildings and geometric objects. A right-angle ruler is useful for perpendicular lines, like when drawing comic book panels.

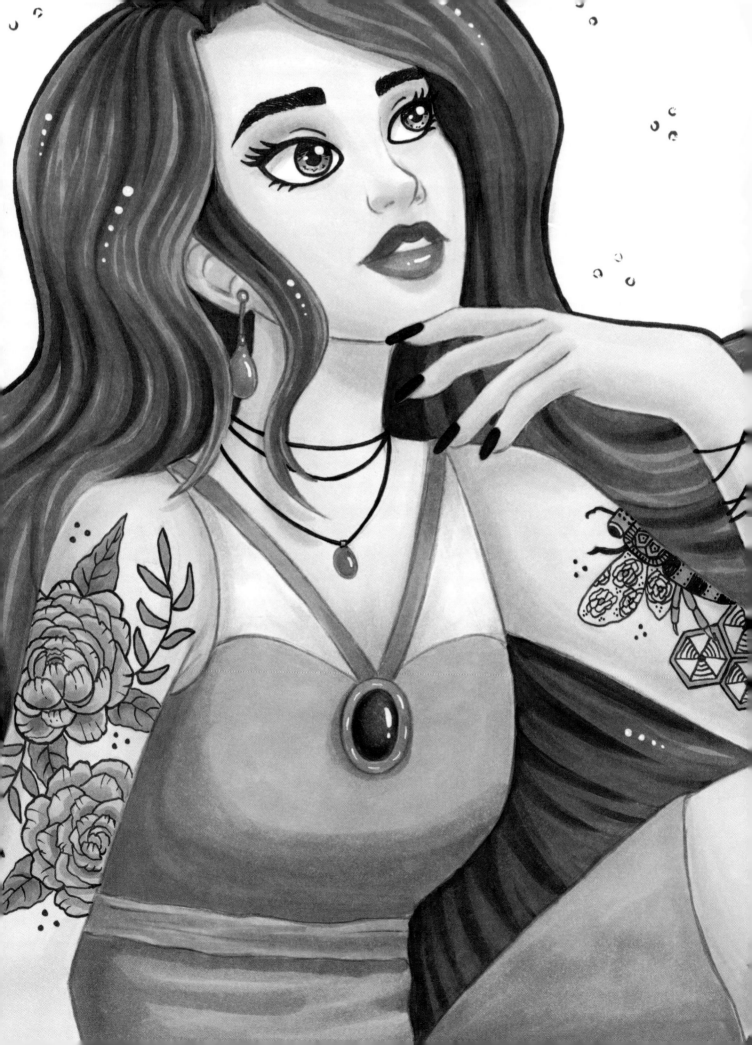

Sketching & Inking

Once you've assembled some supplies, it's time to sit down and create! You have a blank piece of paper in front of you, but what do you draw? The lessons in this chapter will help inspire you to come up with some cool character designs. You'll also learn tips and tricks for inking your sketches to prepare them for coloring.

Keep in mind that these tutorials focus on a specific art style, so feel free to tweak the way things look to make the designs your own. Part of the beauty of art is the freedom to take whatever ideas you have and bring them to life on paper. So let your creativity flow!

Setting Up Your Workspace

Before you can start sketching away, you need to figure out where to set up your workspace. You could curl up on the couch with a sketchbook or annoy your mom by taking over the kitchen table. Any space can work, but eventually you'll get tired of being interrupted by family members or get sick of having to stow away all your supplies each day. If you'd like to set up your own personal space, here are some things to consider.

DRAWING SURFACE AND LOCATION

The main things you need are a flat surface to draw on and a chair. It doesn't have to be fancy, but having your own desk is a plus. It's wise to invest in a comfortable chair if you plan to be drawing for long periods of time. You'll also want a bright lamp to light up your space. It's ideal to have your art space somewhere private, away from the distraction of family members. This could mean having a desk in your bedroom or a quiet corner of the house.

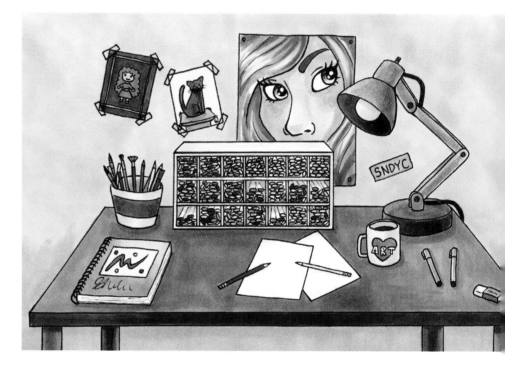

GETTING ORGANIZED OR NOT

If you have a lot of supplies, you'll want to keep them somewhat organized. I like to keep the materials I use the most—pencils, erasers, ink pens and markers—on top of my desk so they're easily accessible. Everything else gets shelved or tucked away in drawers or cupboards when not in use.

It can be tough to keep the area clean, and I will admit my desk is usually pretty messy. If I just finished drawing something, it looks like a tornado ripped across my desk, throwing art supplies everywhere. As long as the clutter is art-related, I'm fine with it!

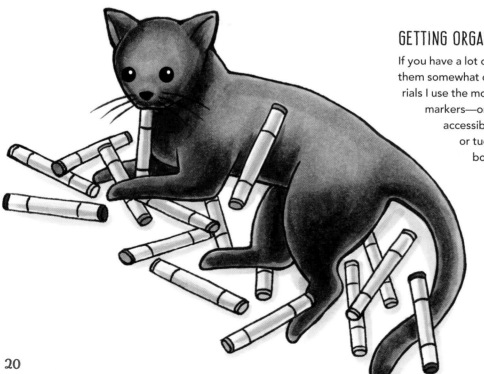

ATMOSPHERE

Instead of a plain workspace, try dressing it up with inspirational decorations. Hang art prints from your favorite artists or posters from your favorite movies, or display dolls and figures from shows you like. Have art books and magazines nearby in case you need a dash of inspiration. Being surrounded by creativity can motivate you and get you in the mood to draw.

AVOIDING DISTRACTIONS

Even if you're tucked away in your own little space away from other people, distractions can easily arise. Your phone and computer give you instant access to the Internet, an endless black hole of entertainment that is difficult to climb out of. Get in the habit of taking designated breaks to check e-mails, social media or anything else that might tempt you.

However, what one person considers a distraction, another might see as a useful drawing aid. For example, I like watching movies or listening to audiobooks while I draw. If it's something visual like a TV show or movie, I make sure to watch something I've already seen, or something not overly interesting so it doesn't take my attention off my art. Some people prefer listening to music as they work, and others need to have complete silence.

What to Draw

A common struggle all artists face at some point (or all the time) is not knowing what to draw. From your perspective, it might seem like artists around you have an endless supply of ideas and creativity, but many of us do struggle behind the scenes. It's important to push past this and not let it prevent you from creating.

GETTING INSPIRED

You're sitting in front of a blank piece of paper, and nothing is coming to mind. Here are a few things you can do to give your brain that extra kick it needs to come up with an idea:

- Keep a folder on your computer containing art by your favorite artists. Flip through the pictures—maybe something will ignite an idea.
- Go outside and take photos. Then try drawing some of what you captured.
- Make random scribbles; maybe they will start to resemble something.
- Pick out three different objects in your room and combine them into a character.
- Open a big book like a dictionary or a novel and draw one of the first words you see.
- Draw something related to current events or holidays.
- Use a website or an app that will give you drawing prompts.
- Create an art challenge for yourself, such as drawing blindfolded, upside down or with your foot. This will get your brain to think differently.

WHERE DO IDEAS COME FROM?

When inspiration strikes, it can be hard to explain exactly where the idea came from. Sometimes it's obvious; maybe you feel compelled to draw one of the characters from an animated movie you watched recently, or you were just at a zoo and now you want to draw one of the animals you saw. On the other hand, sometimes ideas just randomly pop into your head. A purple octopus with pink polka dots riding a unicycle? Sure, why not?

Then there are times when no matter how hard you try, you can't think of a single interesting thing to draw. When an idea finally materializes, it's usually a result of past memories or subconscious thoughts that rise to the surface. So it's important to go out and live your life to give your brain more fuel for ideas!

Tip

Use your phone for jotting down drawing ideas. You never know when an idea will strike!

The Importance of Practice

A mistake many beginners make is believing there is some magic secret to becoming a good artist. The answer is simply that you have to practice. A common saying is that it requires 10,000 hours of practice to master something. Another is that we all have 10,000 bad drawings in us, and we need to get them out as soon as possible. Obviously some people learn faster than others, and art skill is subjective, but those sayings make a good point. The only way to get better at anything is to put in time and effort.

DRAW EVERY DAY

Some artists strongly believe you must draw every single day in order to improve, even if it's only for 15 minutes. Personally, I think it's completely acceptable to skip some days. Just keep in mind that the more you draw, the faster you will improve. If you're feeling burnt out, it's OK to take a break, but if you're frustrated that you're not making progress, buckle down and draw more. Don't let excuses stop you from achieving your goals.

KEEP A SKETCHBOOK

Drawing in a sketchbook is the perfect way to practice without pressure. Don't be intimidated by some of the fancy, detailed sketchbooks you see online that have every page stuffed with colorful, polished art. The purpose of a sketchbook is not to create pretty, finished pages—it's a place to be messy and to explore. If a drawing goes wrong, move on to the next sketch. Don't rip out pages or scribble out drawings. A bad idea might lead to a good idea in the future. Just let your thoughts flow!

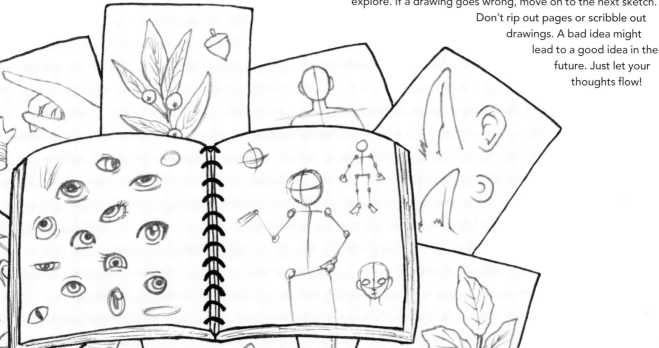

DRAW A BASIC HEAD

When designing a character, the head is usually the first thing you draw. It's also one of the first things we look at when we see a character. The face can reflect a character's personality, age, race and more.

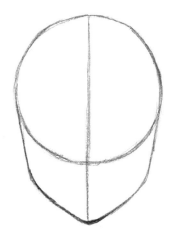

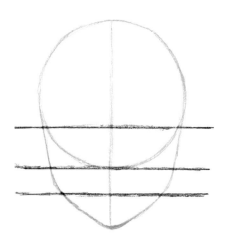

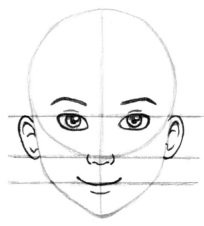

1 DRAW THE BASIC SHAPE
Start by drawing a circle. Draw a line straight down the middle, making sure it goes past the bottom of the circle. Then draw in the jaw and chin.

2 ADD GUIDELINES
Guidelines will help you line up the facial features. Draw the first line halfway between the top of the head and the chin. Draw the next line halfway between the first line and the chin. Draw a third line halfway between the second line and the chin.

3 ADD FACIAL FEATURES
Draw the eyes on the top line, the nose on the middle line and the mouth on the bottom line. The ears should sit between the top and middle lines.

4 CLEAN UP AND ADD DETAILS
Erase your guidelines and refine the details of the face.

Tip

Everyone is unique! Change facial proportions to give your characters more variety!

Demonstration
DRAW EYES

Eyes are the most important feature of the face. They're often the first thing you look at when you see a person's face, so you want your character's eyes to leave an impression. The way eyes are drawn can drastically change the style of your art. They're also the main indicator of your character's emotions.

MATERIALS

eraser
HB pencil
sketchbook paper

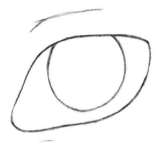

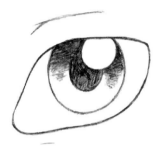

1 DRAW THE BASIC SHAPE
Draw the basic shape of the eye (known as the lash lines). Pay close attention to the shape you wish to make the eye.

2 ADD THE IRIS AND EYELID
The iris usually touches the upper lash line. It can be drawn as a circle or an oval. Place a line above the upper lash line to suggest the eyelid.

3 ADD THE PUPIL AND HIGHLIGHTS
Draw the pupil and then shade the top of the iris since the eyelashes cast a shadow onto the eye. Add the main highlight in the upper corner of the iris. You can add additional smaller highlights if you like.

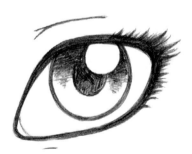

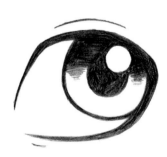

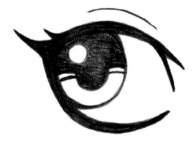

4 THICKEN THE LASH LINES AND ADD EYELASHES
Thicken the lash lines, making them thickest in the outer corner of the eye and gradually thinning toward the inner corner of the eye. To draw the eyelashes, start at the lash line and flick your pencil outward to create a tapered stroke.

PLAY WITH SHAPES AND DETAILS
Try drawing various shapes and sizes of eyes. A mean character might have small pointy eyes, while a kind character might have large round eyes. Some characters might have more eyelashes, more highlights or more creases around the eyelids.

Demonstration
DRAW NOSES

Noses don't have to be complicated, especially for cartoon art. They can be simple curved lines, a small dot or absent altogether.

1 DRAW THE TIP OF THE NOSE AND THE NOSTRILS
Draw a simple curved line to form the tip of the nose. Then draw nostrils on either end of this line.

2 DRAW THE OUTER EDGES
Create the outer edges of the nose by simply drawing brackets around both nostrils. Finish by adding a small curved line on top of the nose to give it some shape.

TRY DRAWING OTHER SHAPES AND ANGLES

Play around with different nose shapes. Noses can be pointy, round, turned up, turned down, wide or narrow. Some noses are hooked, and some have bumpy nose bridges. Sometimes the bridge of the nose isn't drawn at all.

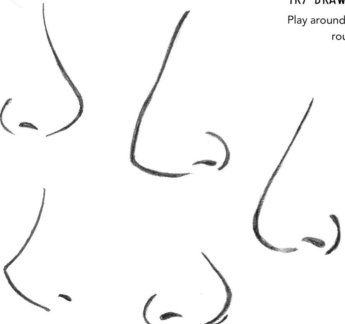

SIMPLIFIED NOSES

Some noses are made using one simple curved line or by drawing one or two small dots.

26

Demonstration

DRAW MOUTHS

There are many ways to draw mouths, but you can't go wrong with a simple design. Once you master drawing a regular smiling mouth, play around with different expressions.

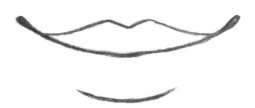

MATERIALS

eraser
HB pencil
sketchbook paper

1 DRAW THE BASIC SHAPE
Draw a curved line to form the basic mouth shape. Thicken the corners of the line to add depth.

2 DRAW THE LIPS
Draw the upper lip like the letter M but stretched out. Then draw a simple curve for the lower lip.

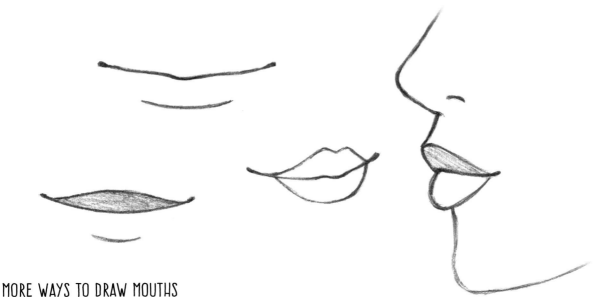

MORE WAYS TO DRAW MOUTHS

Sometimes the mouth is one simple line, and other times there is more detail. The upper lip is normally drawn only on female characters but can be drawn on males, too. The upper lip is usually darker than the lower lip since it doesn't catch as much light. Sometimes the philtrum (the dent above the upper lip) is less pronounced, or it may be absent altogether.

Demonstration
DRAW EARS

Ears have quite an interesting shape, and all the curves and folds can be intimidating to draw. The key with cartoon art is to simplify the shapes.

MATERIALS

eraser
HB pencil
sketchbook paper

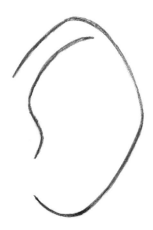

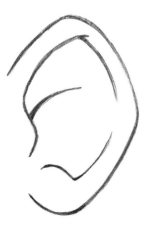

1 DRAW THE BASIC SHAPE
Draw a curved line to form the basic shape of the ear. Think of the ear shape as the letter C, or in this case, a backwards C. You can also think of it as a diamond with round corners.

2 ADD THE INNER CREASE
Draw an S-shape within the curve of the main shape. Make sure the top of the S is longer than the bottom.

3 ADD DETAILS
Draw a line starting from the top of the S, curving in the same direction as the outer ear. Leave a gap, then begin the line for the lobe of the ear. Shape it like a curvy check mark. Then draw a curved line in the middle of the ear and connect it to the S curve.

MORE EAR SHAPES

It's tempting to draw ears the same way every time, but just like other facial features, ears are unique, too. The first ear in this example was drawn from the front. It looks narrow, and some lines overlap each other. The second ear has a very round shape, and the last ear is pointy.

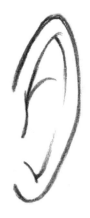

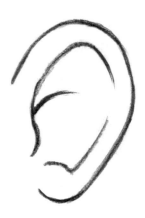

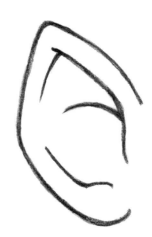

Hair

Hair comes in all shapes, sizes and colors, especially when it comes to cartoon art.

SIMPLIFY HAIR INTO BASIC SHAPES

Although it may seem complicated to draw because of all the hair strands, hair can be simplified into basic shapes and sections. This not only makes drawing hair easier, it also makes the design look better.

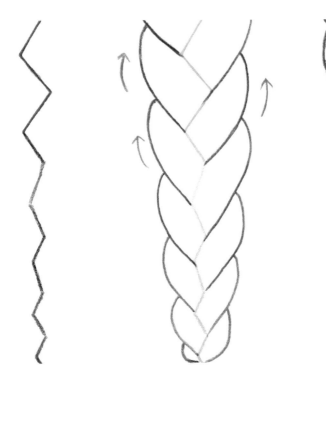

DRAWING BRAIDS

To draw a braid, simply start with a zigzag line, then extend those lines upward using a curved line.

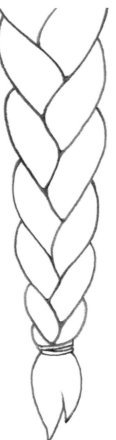

Demonstration
DRAW HAIR

The same steps can be applied when drawing all kinds of different hairstyles. Look up pictures in magazines or online, or come up with your own designs. The key is to think of the overall shape of the hair before you start drawing.

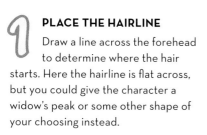

MATERIALS

eraser
HB pencil
sketchbook paper

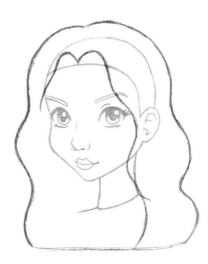

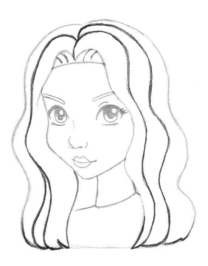

1 PLACE THE HAIRLINE

Draw a line across the forehead to determine where the hair starts. Here the hairline is flat across, but you could give the character a widow's peak or some other shape of your choosing instead.

2 DRAW THE BASIC SHAPE

Draw the outline of the hair by making wavy lines starting at the top of the head. Draw in the shape of the bangs as well. This will help you establish the overall style and silhouette of the hair without having to worry about details yet.

3 BUILD UP LOCKS OF HAIR

Draw in more wavy lines to show the different locks of hair. Instead of drawing tons of hair strands, think of the hair as big chunky sections. Some of these locks will overlap.

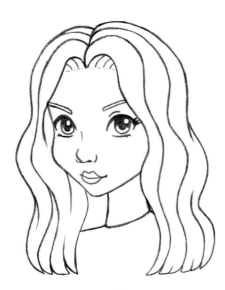

4 ADD DETAILS

Add details by drawing a few extra lines at the bottom of the hair and at the roots. These lines should be connected only on one side. Also add some of these lines on the outer edges of the hair to make it look like some pieces are overlapping others. Clean up your lines, and then you're done!

Hands

Hands are one of the most daunting things to draw for many new artists. There are so many parts and joints, which can be overwhelming and difficult to piece together.

BASIC SHAPES

The palm of the hand is like a square that narrows at the wrist. A triangle drawn on the side of the square can help you position the thumb. If you draw a line down the middle of the fingers, those lines should converge at the wrist. It's also important to note the two fatty parts of the palm: one at the base of the thumb and one under the pinky and ring fingers. The palm is not flat and stiff—it's flexible and can fold, causing these fatty areas to squash together and stretch apart.

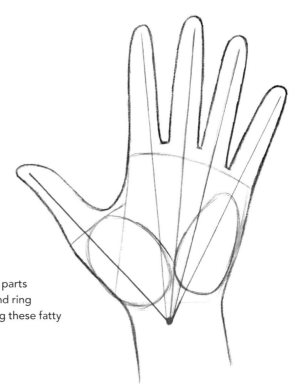

GETTING POSES RIGHT

One thing that makes hands difficult to draw is that they can be posed in a wide variety of positions. Practice drawing hands using stock photos or photos of your own hands. Try not to get caught up in all the tiny details at first. Focus on how each part relates to the next part, instead of all the tiny creases and details. Cartoon hands usually leave out a lot of fine detail anyway. Often, cartoon characters don't even have fingernails!

Feet

Although most characters wear shoes, it's important to know how to draw bare feet. Knowing the basic construction of the foot will help you draw any type of shoe for your character. Whether the characters wear sneakers, sandals or nothing at all, you'll need to know how to draw feet.

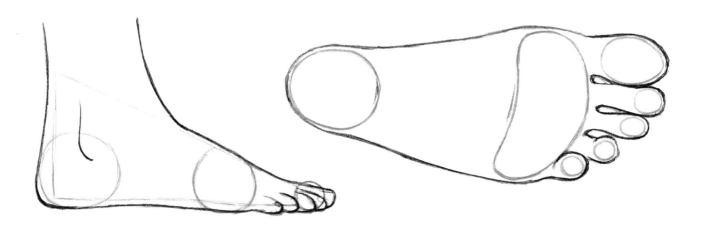

BASIC SHAPES

The basic shape of the foot is a triangle. If you can draw a triangle, you're halfway there! The fatty areas are where the foot makes contact with the ground. When the foot is raised, these areas will be rounder. When the foot steps down, these areas squash against the ground, making them flatter.

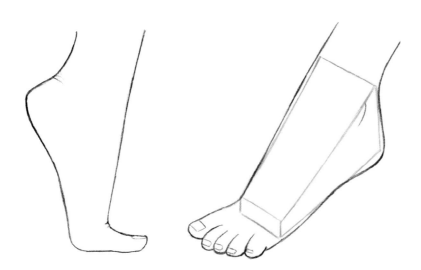

PRACTICE

Practice drawing feet using photos. Draw as many different positions as you can.

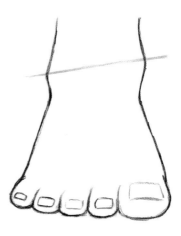

HI-LO RULE

When drawing the ankles, always remember the HI-LO rule: high inside, low outside. This means the outer ankle is lower than the inner ankle.

Drawing Bodies

Are you drawing heads over and over because you don't have the confidence to draw full bodies? We've all been there at some point. The key to drawing bodies is to know the basic structure. Once you have that down, you can apply it to any body type or pose.

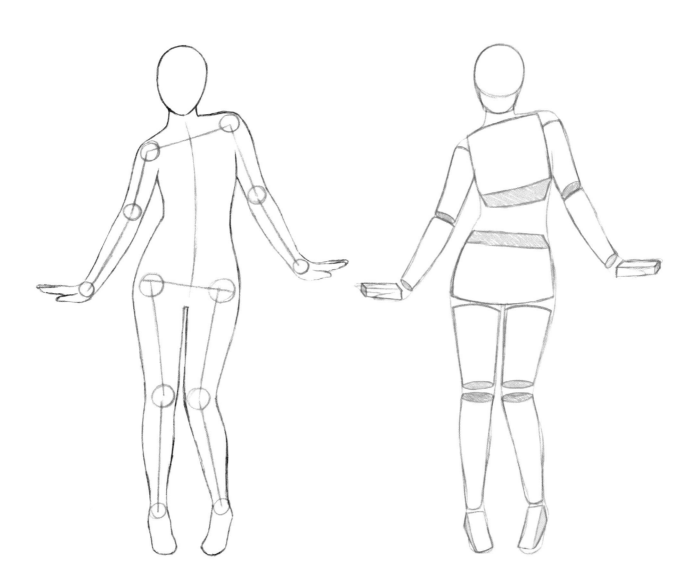

SKELETON AND STRUCTURE

The easiest way to start drawing bodies is to create a skeleton using lines and circles. You're not actually drawing bones, but you are mapping out the location of body parts. Use circles to represent joints. Draw lines to connect them. It's a great way to plan out poses and proportions without wasting time on details.

Another approach is to draw 3–D shapes like cubes and cylinders to represent sections of the body. This method is more advanced, but it's useful for figuring out tricky poses—especially when positioning the torso. Start with a skeleton and draw the structural shapes on top. Once you're happy with the skeleton and structure, start fleshing out the character. It's always best to draw a basic bare body before adding hair, clothes and accessories.

Body Proportions

People come in all shapes and sizes, so don't feel limited to one way of drawing bodies.

HEAD MEASUREMENT

When describing proportions, a character's height is usually measured in heads. Here, the man is about 7½ heads tall, while the woman is just under 7 heads tall. This measurement can vary a lot, since we're not all the same height. Females are usually shorter than males but not always. Proportions can also vary by age, body type and art style. Try switching up stereotypes by making a muscular woman or a feminine man. The possibilities are endless!

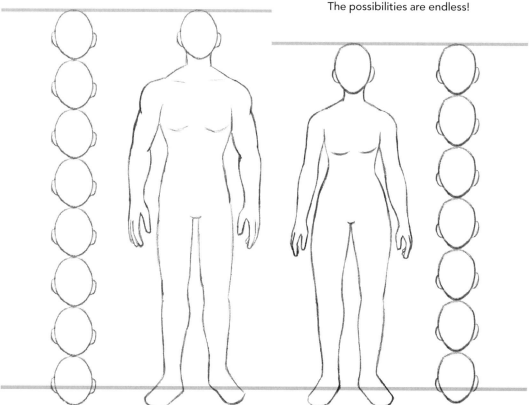

VARIATION

Is your character overweight or slender, tall or short, muscular or scrawny? Do they have broad shoulders or broad hips? Are they missing an arm or a leg? With variables like these, there aren't just two options. People's shapes and sizes exist along a spectrum because we're all unique.

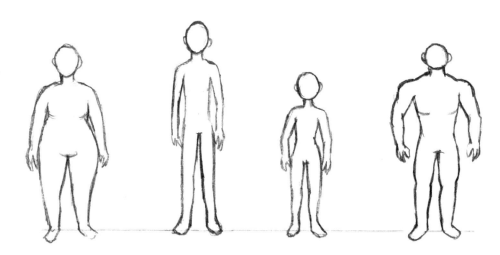

Poses

Coming up with poses can be tricky. After a while, it starts to feel like you're drawing the same old poses repeatedly. For some fresh ideas, try taking photos of yourself or a friend in various poses. Try looking at yourself in a mirror. There are also many great websites that provide stock images for pose reference. Poseable mannequins can be fun, but most aren't articulate enough to give you quality reference.

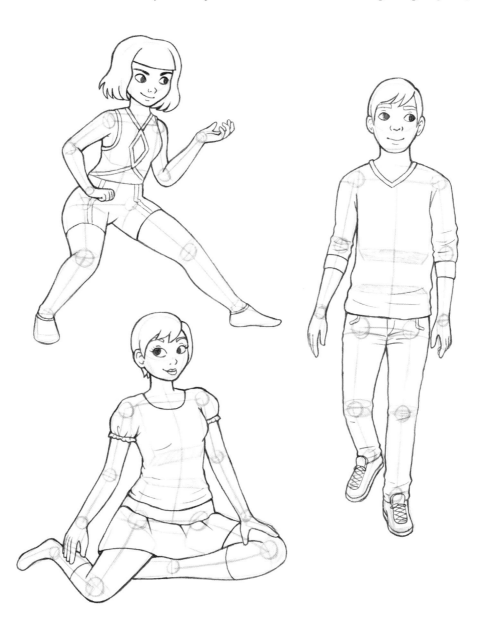

DRAW AN ACTION

A good way to come up with a pose is to think of a specific action the character is doing. Instead of having them standing still, maybe the character is walking. Instead of sitting on a chair, they can be sitting on the ground in an interesting way. Maybe the character is in the middle of a fight scene or is eating some food. Any action is more interesting than a character who's doing nothing.

PUSHING THE POSE

Once you have an idea for a pose, try to push the pose to be more extreme or more dynamic. The line that describes the overall shape of the pose is called "the line of action." Ideally, it should always be in the shape of a C or an S unless the character is meant to be stiff to express a certain emotion.

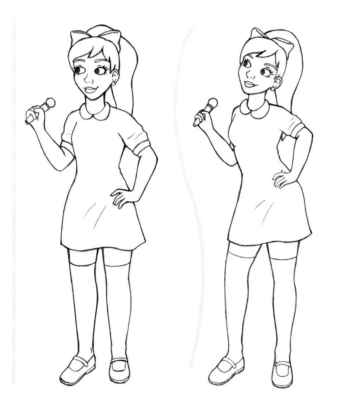

EMBRACE CURVES

In the first image, the girl is standing very straight, which is pretty boring. In the second image, her head is tilted back, her hips are pushed out and there is more bend to one leg. This changes her line of action from a straight line into a nice S curve.

GIVE YOUR POSES SOME PUNCH

In the first example, the man is punching at something, but the pose is weak and not very dynamic. In the second example, his body leans in a more extreme direction, and one leg is raised. Now he has more movement, and his punch looks more powerful. His line of action becomes a strong C curve.

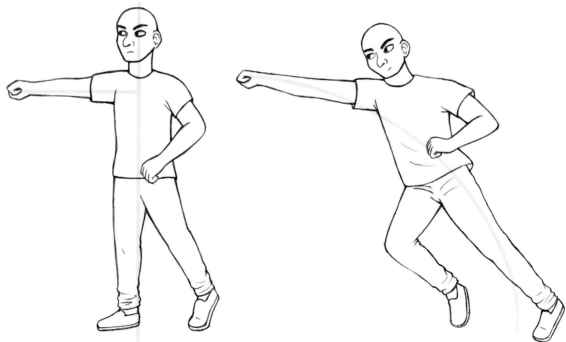

Clothes

Clothes say a lot about who a person is. They reflect the personality of the character you're drawing, so be sure to put some thought and planning into your clothing designs. A character who is prim and proper won't be walking around town in sweatpants, and a character who is a slob won't be sitting around the house in a fancy suit. Outfits are dependent not only on personalities but also on the situation your character is in.

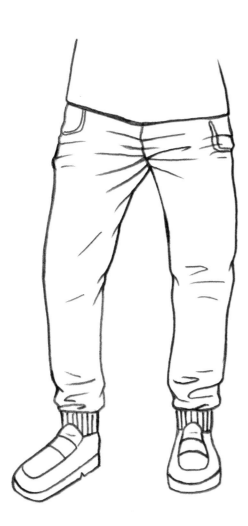

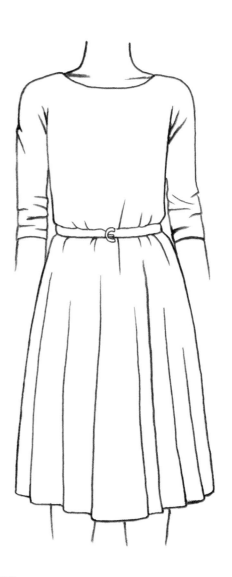

CREASES AND FOLDS

The key to drawing fabric is to know where to place creases and folds. Think about where the fabric bunches up. A good rule is to always place folds in areas where there are joints, like the knees, elbows and ankles. With pants, there are usually a lot of creases near the pelvic joint as well as at the ankles where the fabric gathers. There will also be some creases near the knees. The more a joint is bent, the more the fabric will bunch up.

CINCHING

Here, the belt is cinching in the waist of the dress, causing small vertical wrinkles along the belt. Also notice how the fabric spills over the belt along the edge of the waistline.

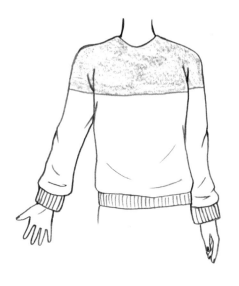

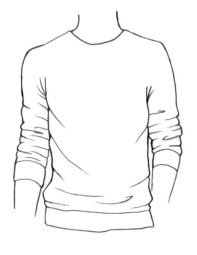

NO

The edge of clothes will not be flat where there are folds.

THICK VS. THIN, TIGHT VS. LOOSE

Look at these two sweaters; the one on the left appears to be made of thicker fabric since it has fewer folds and hangs looser on the body. Generally, tight or thin clothes have more creases, and thick or loose clothes have fewer. The way the clothing is worn also affects things. The sweater on the right has its sleeves rolled up, causing even more folds than usual.

YES

The folds are visible along the outline of the character, creating bumps.

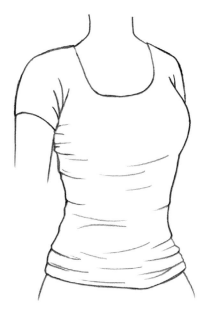
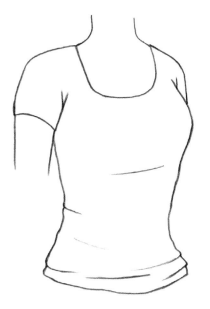

DON'T OVERDO IT

Adding too many wrinkles can make the outfit look off. The shirt on the left was drawn exactly as it looked from a reference photo, but it didn't translate well into a cartoon style. The same shirt is pictured on the right, but I removed a lot of wrinkles to simplify the design.

DETAILS MUST FOLLOW THE FOLDS

Any seams, patterns, zippers or pockets must follow the shape of the folds. Notice how the zipper and pockets are not drawn as straight lines here.

DRAW RIPPLED FABRIC

This technique is handy for drawing draped fabric, such as ruffles, and clothing, such as skirts and dresses.

1 START WITH A WAVY LINE
Draw a wavy line. Imagine the line is made of hills and valleys.

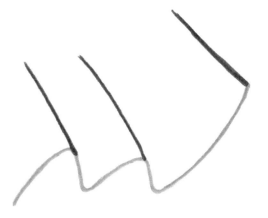

2 ADD LINES ON TOP
Draw straight lines extending out from the tops of the hills.

3 ADD LINES ON BOTTOM
Draw straight lines extending out from the bottoms of the valleys. It's that simple!

Accessories

To make your characters stand out from the rest, give them some distinctive accessories. The possibilities are endless, but here are a few ideas.

SHOES AND BAGS

When it comes to shoes and bags, think hard about the 3–D structure of the items. For example, a purse is not a simple flat rectangle—it has thickness and shape. The same goes for shoes. Observe their construction and shape. Notice where different pieces of fabric are stitched together and how they overlap. For both shoes and bags, adding dotted lines to represent stitching can add a nice, realistic touch.

JEWELRY

Jewelry can be worn almost anywhere on the body, and each item of jewelry is its own piece of art. These are just a few simple ideas as to what your characters can wear. Make sure all jewelry wraps around the form of the body. For example, notice how the rings are curved lines that actually wrap around the fingers instead of being simple straight lines.

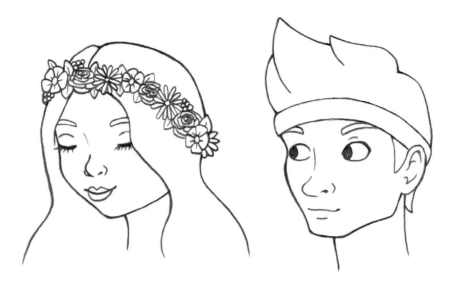

HEADBANDS

Whether it's a simple sweatband or an intricate floral crown, headbands add a great touch to your character designs. Just make sure they follow the curvature of the head.

HATS AND SCARVES

There are so many types of hats that exist—try drawing a bunch of different styles. You can even decide how a specific hat is worn. Is it straight on top of the head, or does it sit farther back? Does it have a tilt, or is it slightly rotated? There are multiple ways to tie a scarf, so practice drawing lots of those, too. The fabric itself can be thick or thin. It can sit under the jacket, on top, around the neck, over the face, over the head and more.

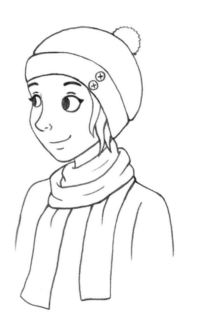

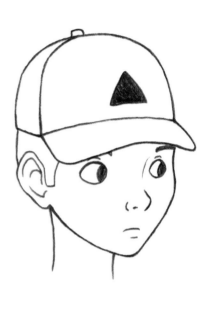

HAIR ACCESSORIES

Try giving your character hair clips, hair ties, bows and more. A simple detail like a hair clip can be a distinctive, recognizable feature about your character. No detail is too small to be overlooked.

Thumbnails

A thumbnail is a small messy sketch used to plan your drawing. Think of it as the sketch before the sketch: quick, simple doodles that map out what elements go where, how the character is posed, what colors you plan to use and more. It's a great way to avoid mistakes down the road, and since a thumbnail is so quick to make, you can explore a wide range of ideas before committing to one.

PRELIMINARY THUMBNAILS

Here are some examples of thumbnails that I drew before I even started on my sketches.

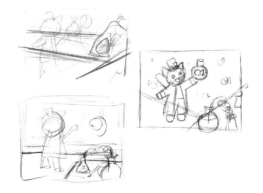

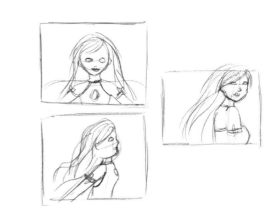

Silhouettes

Imagine taking one of your drawings and coloring the whole character pitch black. Would the pose or action still read clearly? If not, you need to rethink the character's silhouette.

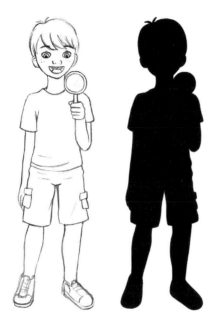

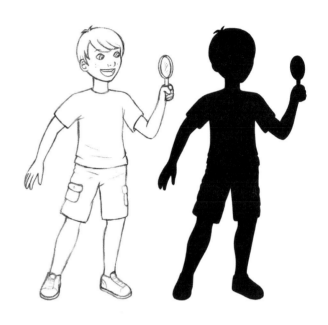

NEEDS IMPROVEMENT

If you look only at the silhouette, it's hard to know what the character is doing. The magnifying glass, which is the driving force of the character's action, overlaps with his body. His other arm is draped at his side, which doesn't add anything to the pose and makes the silhouette even less clear.

MUCH BETTER

By turning him to the side a bit and pulling the arms away from his body, the pose is more clear. If there is a prop driving the character's action, that prop needs to read clearly. Even without a prop, you should be thinking about the overall body silhouette.

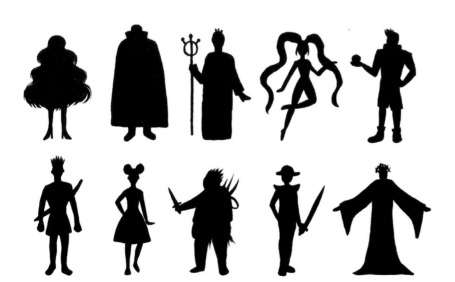

IT'S NOT JUST ABOUT THE POSE

It's helpful to think of silhouettes when designing your character's body type, clothing, hair and accessories. Here are some examples of designs created with the silhouette in mind. You should be able to guess what the characters might look like based solely on their silhouettes.

Composition

When putting your character into a scene, it's important to think about the composition, which is the placement of all elements in the scene. Composition is used to draw the eye to a specific focal point in the image and to make the image more visually interesting. Below are just a few of the many tips and tricks to creating great compositions.

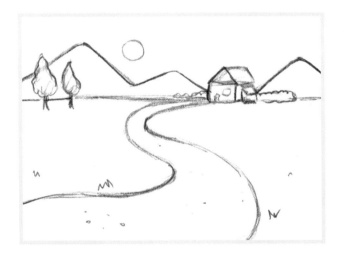

LINES AND CURVES

The use of lines, straight or curved, can be used to build a scene. Here, the winding path leads the eye to the focal point—the house.

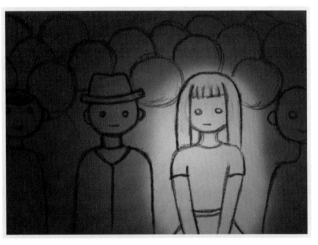

LIGHT AND VALUES

Use lights and darks to bring attention to a specific area in your art. Here the woman is the focus, so everyone else in the crowd is in shadow.

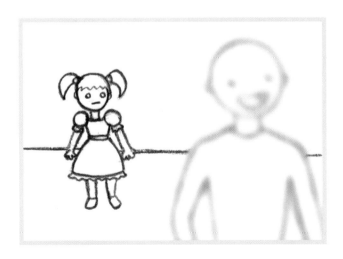

FOCUS AND DEPTH

Draw attention to a specific subject by blurring other areas, like the background or foreground. The man in this picture is blurred to turn our focus onto the little girl.

COLOR

Give the focal point a different color than the rest of the scene to make it pop.

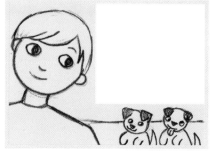

GEOMETRIC SHAPES

Use shapes like triangles and rectangles to build your composition. In the first example, the woman and her hair create a triangular shape. In the second example, the man and his dogs create an L shape.

RULE OF THIRDS

If you make a 3 × 3 grid on your paper, the areas where the lines intersect are considered the most visually interesting areas to place your subject.

AVOIDING TANGENTS

Visual tangents occur when objects overlap or touch in unpleasant ways. They should be avoided as much as possible.

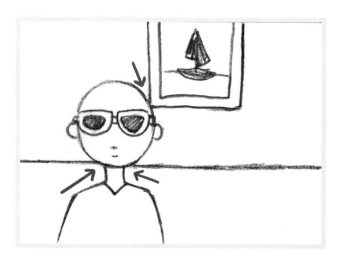

EXAMPLES OF TANGENTS

Here the corner of the picture frame touches the edge of the man's head. This is a tangent that needs to be fixed. Either his head needs to overlap with the frame, or they need to be separated. Also notice how the line of the floor aligns with where his neck meets his head.

TANGENTS FIXED

The picture frame was moved to the right so there's now a gap between it and the man's head. The floor line was also moved down. The composition looks less crowded and awkward now.

Preparing Your Sketch for Inking

If you want to ink a drawing, there are two ways to go about it. You can ink directly on top of your sketch and erase your pencil lines, or you can trace your sketch onto a new piece of paper. If you plan on coloring your art, I recommend tracing it onto a new piece of paper. Sketches done in a sketchbook or on printer paper should always be traced onto nicer paper before inking and coloring.

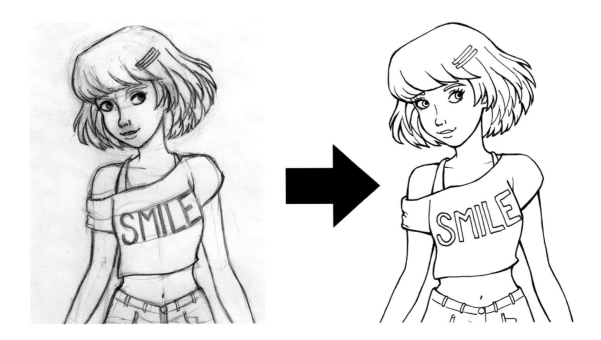

BENEFITS OF TRACING

I sketch with quite a heavy hand, so my pencil lines never erase completely. By tracing onto new paper, the inks look much cleaner. Another benefit is my original sketch remains intact. Sketches have a rough, flowy look to them that often gets lost once you ink, so it's nice to have the original sketch to refer to. Also, if you make an inking mistake, you can start over on a new piece of paper.

HOW TO TRACE YOUR ART

The main method for tracing is to use a lightbox. This is a light encased in a flat box with a Plexiglas top that allows the light to shine through. Lightboxes can be expensive, but you can make your own using a light source and any clear surface. Take a sheet of plastic or glass and prop it up with a light underneath. Picture frames are an easy source of plastic or glass, and battery-operated lights are the easiest to use. You can use anything from blocks of wood to tissue boxes to prop up the glass. You can even build a box to place the glass on using wooden planks.

A simpler way to trace your sketch would be to hold your art up to a bright screen or a window. Make sure to dim the lights in the room so you can see through the paper more easily.

Preventing Ink From Smudging

If you plan on coloring your inked drawing, it's important to think ahead. The coloring tools you're using might not be compatible with your ink, causing the ink to smudge. You'll have to do some tests to see what tools work together.

For example, if you're using watercolor paints, you need to make sure the ink is waterproof. Sometimes this is written on the product packaging, but not always. If not, try looking it up online so you don't have to waste your money testing different inking tools.

If you're using colored pencils, you typically don't have to worry about smudges because colored pencils are not a wet medium. If you're using alcohol-based markers, you'll need an ink that's alcohol-proof.

	WATER	MARKERS
Ink #1		
Ink #2		
Ink #3		

MAKE A CHART

Take a few inking tools you have and put them to the test. Make a chart similar to this one and color over it. Use a variety of ink strokes in the test since thickened areas tend to be more prone to smudging. Make sure the ink is fully dry before you start your tests.

Tip

If using alcohol-based markers, you can scan your line art, print it out and then color on the printout. Most printer inks won't smudge with markers.

Line Weight

Line weight refers to the thickness of your lines. Even with a single fine-line pen, you can create varying line weight.

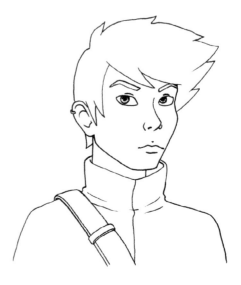

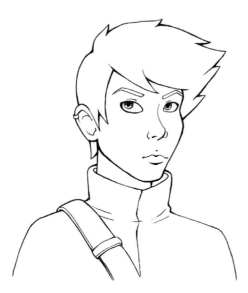

PLAIN LINES

Here the lines are all about the same thickness from start to finish. It's perfectly fine to leave your lines like this, but I like to add more variation.

THIN LINES WITH VARYING WEIGHT

Here the lines are thin, but they thicken in certain areas. Typically, areas where lines meet are thickened, as well as areas that are in shadow. For example, if the light is coming from above, the underside of the chin or the underside of a section of hair will be in shadow.

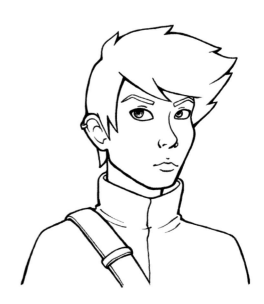

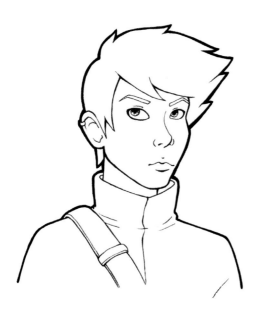

THICK LINES WITH VARYING WEIGHT

This technique is just like the previous one except the lines are thicker. It's all up to your personal preference and what type of look you're going for.

THICKENED OUTER EDGES

Any of the previous techniques can be combined with this one. Here the outermost edges of the character are the darkest. This can help separate the character from other elements in the scene.

LINE WEIGHT WITH A FINE-LINE PEN

With a paintbrush, a brush pen or a brush marker, all you need to do to create varying line weight is to press harder for a thicker line and press lightly for a thinner line. With fine-line pens, you'll need to go back over areas to make the lines thicker.

MATERIALS

black fine-line pen
eraser
sketchbook paper

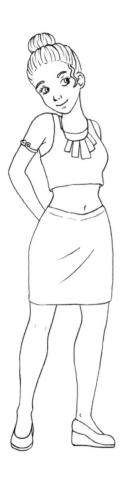

1 DRAW THE BASIC OUTLINE

Ink your drawing without worrying about line weight. Just use one thickness throughout the whole thing. If you've inked on the same paper as your pencil sketch, erase the pencil lines at this stage.

2 ADD LINE WEIGHT

Go back over your lines with a fine-line pen to thicken certain areas. Strokes of hair should be thickest at the base and then taper out. Thicken the chin more than the rest of the jawline. Notice other thickened areas like the elbow, the armpit, where the legs meet the skirt, and anywhere else there's a bend or where lines meet. Thicken the outermost lines as well as the undersides of clothes and body parts. There are no hard rules. Thicken wherever you feel it's appropriate. (Sometimes I thicken a line because there was a small inking mistake I'm trying to hide, or I'm trying to smooth out a shaky line.)

Ink vs. Pencil

When outlining your drawings, you can use colored
pencil instead of ink to give your art a different look.

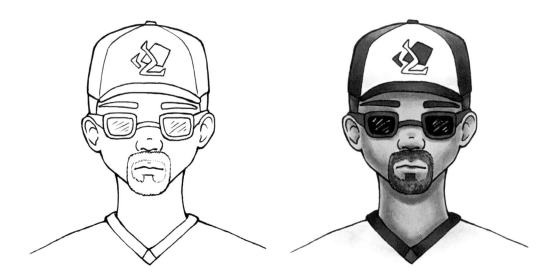

INK LINES

Here the character was outlined in black ink. It creates a bold, cartoon-like look.

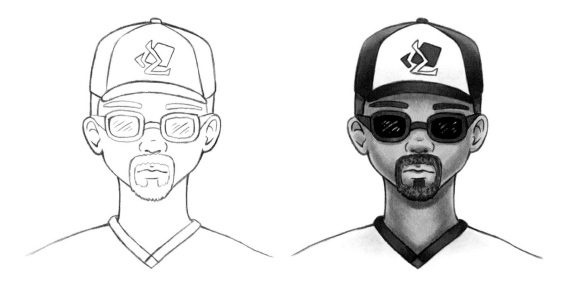

COLORED PENCIL LINES

Here the outlines were done with a brown colored pencil. This gives a softer look
because there's less contrast between the colors and outlines. If you press lightly,
you can make the lines even lighter and less noticeable than this.

Colored Lines

Whether you're using colored pencil or ink to outline, try playing around with different colors. Using anything other than black usually makes your lines less noticeable, which can create a unique look.

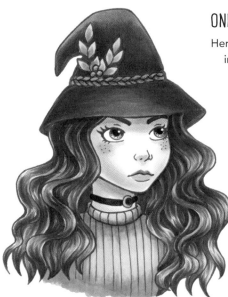

ONE COLOR

Here the character was outlined in one solid color. I chose blue because it goes well with the color scheme. It matches nicely with the purples, blues and greens. It's a nice change from the usual black lines.

MULTICOLORED LINES

Here a different color was used for each section of the character based on how I would color each section. Her hat is inked in blue because it was being colored blue. Her hair was inked purple, and her sweater was inked in green. I also used a bit of orange, brown and black. The outlines are still noticeable, but they don't stand out, which can be a really pleasing look.

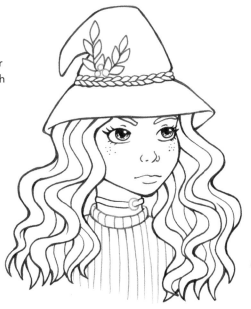

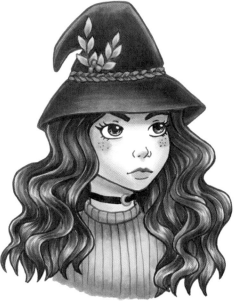

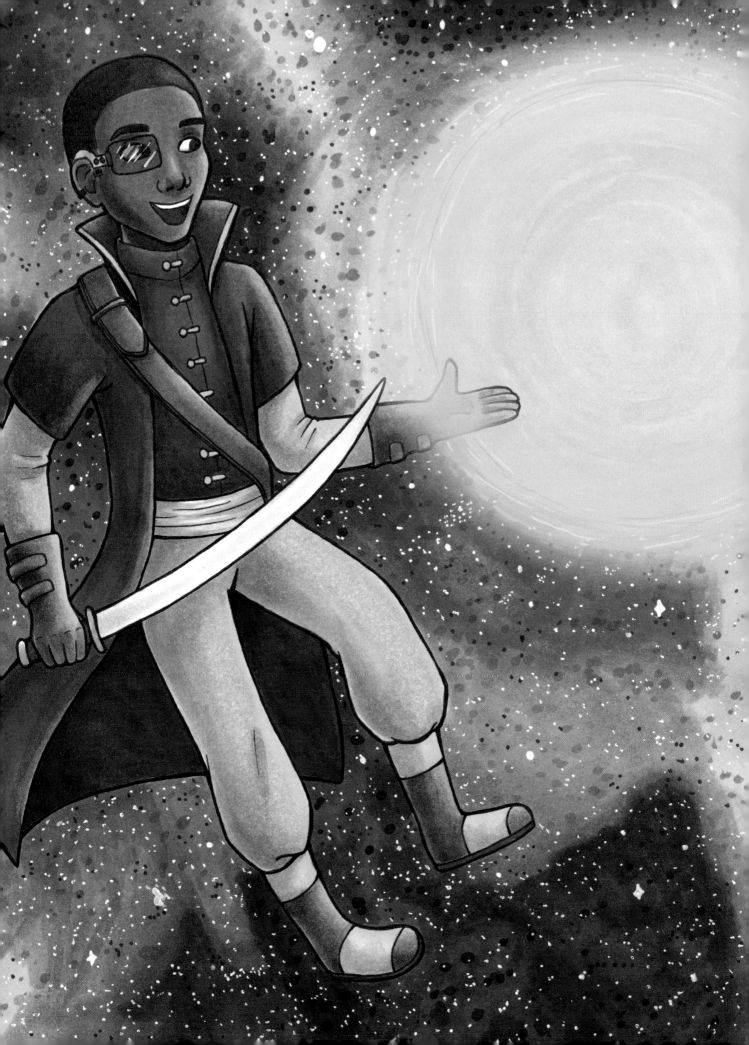

Coloring Techniques

For me, coloring is the most exciting part of the process. There's something about mixing and blending colors that is both pleasing and relaxing. This chapter will explore coloring techniques you can use in your art to re-create several different materials and textures. A lot of focus is on using art markers, but you can also re-create these looks with watercolor paints and colored pencils.

Color Theory

Before you jump into coloring, it's good to know some basic color theory. This will help you understand color terms and make better color choices.

THE COLOR WHEEL

The color wheel is a diagram showing the relationship between colors. They're arranged in the order they appear on the color spectrum, like a rainbow. The outermost ring shows hues, which are the purest form of a color with no white, gray or black mixed in. The second ring shows tints, which are when a hue is mixed with white. For example, pink is a tint of red. Pastel blue is a tint of blue. The third ring shows tones, which is when a hue is mixed with gray. The innermost ring shows shades, which are when a hue is mixed with black.

COLOR TERMS

- **Primary colors:** Colors that cannot be created by mixing other colors. The primary colors are red, blue and yellow.
- **Secondary colors:** Colors created by mixing primary colors. For example, red and yellow make orange. The secondary colors are orange, violet and green.
- **Tertiary colors:** Colors created by mixing a primary and secondary color. For example, mixing blue and green creates a blue-green color.
- **Saturation:** Describes how intense a color is. Primary colors are very bright and saturated. Dull colors such as tones are less saturated (desaturated). They look more gray.
- **Value:** Describes how light a color is. White has the highest value, while black has the lowest value. A light green has a higher value (is lighter) than a dark green.

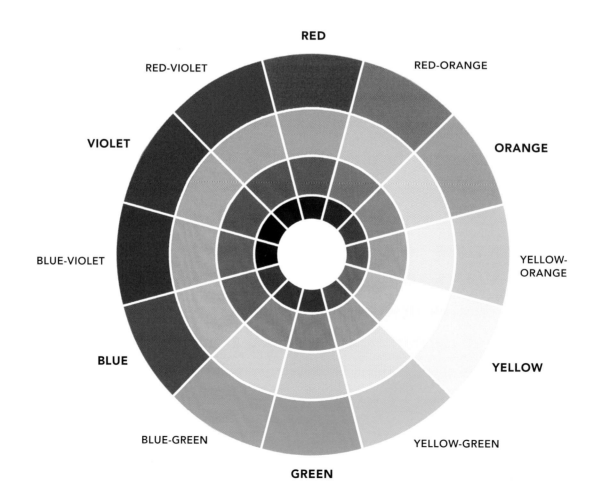

Memorizing a lot of color terms may seem daunting, but you only need to know the basics to get started. You will learn much more once you actually start practicing. As your skills develop, you can seek out more advanced coloring terms and techniques.

Tip

The wheel shows 48 colors, but remember that color exists along a spectrum, so technically your color choices are infinite!

Understanding Values

Let's dive further into value, which is the range of light to dark in an image. This is one of the most important aspects of art to understand when it comes to coloring an image or shading an image if you're working in pencil.

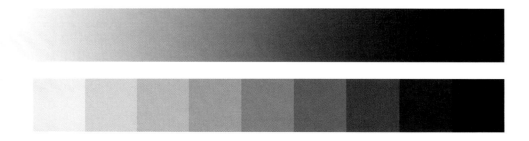

VALUE SCALE

Here is a visual representation of value. Black has the lowest value because it's the darkest, and white has the highest value because it's the lightest. This scale applies to color images as well, not just grayscale images.

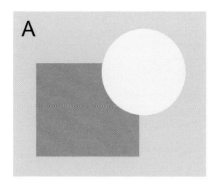

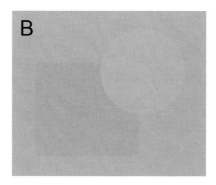

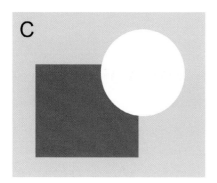

VALUE CONTRAST

If your image was converted from color to grayscale, would the values read properly? In image A, the shapes read somewhat clearly when in color, but once converted to grayscale (image B), the shapes are barely visible against each other. In image C, the purple was darkened and the yellow was lightened, which gives much better value contrast as seen in image D. This shows that color contrast alone is often not enough. Value contrast should also be considered.

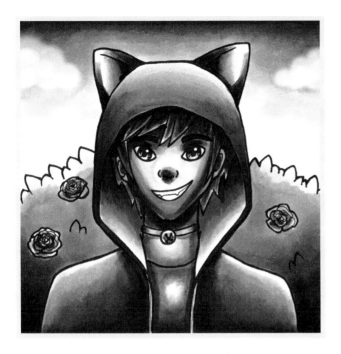

TOO MUCH VALUE CONTRAST

When you first learn to shade in pencil, it's tempting to shade each item from extreme white highlights to extreme black shadows. This is usually incorrect, unless lighting is extreme. When looking at this image in grayscale, it might not look all that bad to the untrained eye. Looking at the same image in color, you can see how extreme and silly the shading looks. Not everything should be shaded from black to white.

 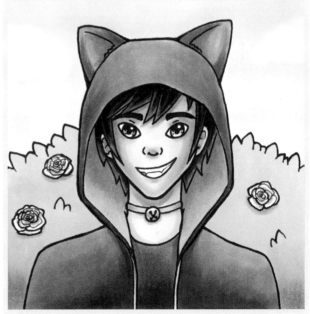

BETTER VALUE CONTRAST

In this example, there is much less contrast. There are still extreme lights and darks in the image, but the contrast in any given section is not extreme. For example, his hoodie goes from a dark gray to a lighter gray, not black to white. The only area that gets dark enough to be black is his hair, and the only white is in his eyes, teeth and the highlights on the flowers. The amount of contrast you have in your image is up to you, but it's best to avoid extremes.

Color Harmony

Color harmony is achieved by using specific color combinations that look good together. Harmonies are also known as color schemes. You can use the color wheel to pick out various color schemes to use in your art.

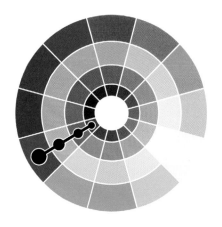

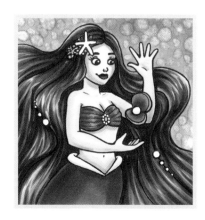

MONOCHROMATIC

A monochromatic color scheme means using tints, tones and shades from a single color family. Here I used only blues.

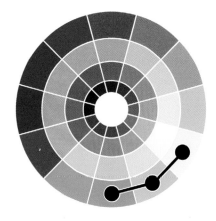

ANALOGOUS

An analogous color scheme means using three or more colors that are beside each other on the color wheel. Here I used yellow, yellow-green and green.

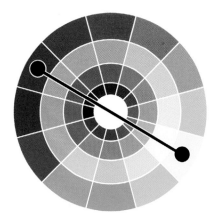

COMPLEMENTARY

A complementary color scheme is when you choose two colors directly opposite from one another on the color wheel. Here I used purple and yellow.

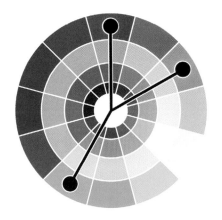

SPLIT-COMPLEMENTARY

A split-complementary color scheme is when you use the two colors on either side of a complementary color. In this case, the complement to blue-green is red-orange, so I chose blue-green, red and orange.

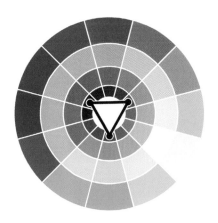

TRIADIC

A triadic color scheme is when you use three colors that are spaced apart equally from one another on the color wheel. Here I used orange, green and violet.

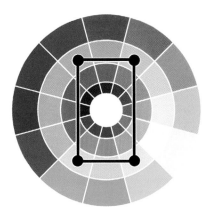

TETRADIC

A tetradic color scheme is when you form a rectangle or a square on the color wheel. A rectangle gives you two complementary pairs. In the case of a square, you use four colors all equally spaced out on the color wheel. Here I used red-violet, red-orange, yellow-green and blue-green.

Laying Flat Color With Markers

I'm often asked how to get flat, even color with markers. Here are a few tips on how to use your markers like a pro.

CIRCULAR MOTIONS

Instead of doing random scribbles, start in one corner of the square and slowly work your way out, using small, circular motions. Make sure the edge where the color meets the white of the paper stays wet. You need to work slow enough that the paper absorbs a lot of ink, yet fast enough that the ink edge doesn't dry.

 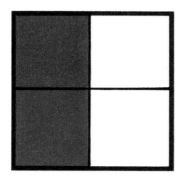

SMALL SECTIONS

Color in one section at a time, even if two sections are going to be the same color. For example, if your character has several locks of hair, color in just one lock at a time. It's easier to get flat color if you're coloring in a smaller area. Sometimes large areas aren't avoidable, so just do your best.

LAYERS

Coloring over the same area more than once helps the color look more flat. It's often difficult to get a flat layer on your first pass, especially in larger areas. I actually don't worry if the ink looks patchy until I'm on my final layer of color. Flat color is achieved when the paper is saturated with ink. You can tell if your paper is saturated by flipping it over and looking at the back. If the ink shows through to the other side, then it's saturated. You don't need to fully saturate the paper, but it helps. Thin papers are easier to saturate than thicker ones, but thicker papers can handle more layering and blending.

Layering

Layering colors allows you to shade your drawing to give it dimension. You don't have to limit yourself to one color family to shade an object. Try shading with different hues to make the colors pop.

LAYERING CREATES NEW COLORS

Notice how new colors are created where the yellow, blue and pink overlap. This is because markers are transparent, like watercolors.

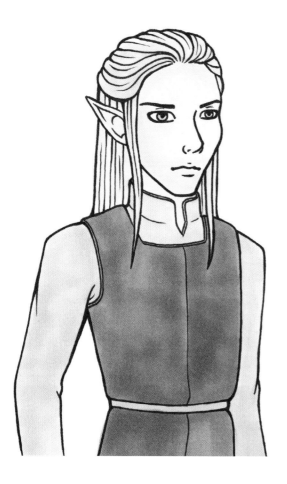

FLAT COLOR

Here's what this character looks like with one color used in each section. He looks very flat since he has no shading. It might seem obvious that he needs shading, but a lot of beginner artists overlook this.

LAYERED COLORS

Here I added shading to his skin, hair and clothes. I added blue to all the shadows to give them more interest and dimension. Another fun option is to add a new hue to the highlights as well.

CIRCULAR BLENDING

This technique is similar to laying flat color. It causes a lot of ink to be deposited, which helps keep the ink from drying quickly. Keeping the ink wet is the key to good blending.

For this technique, color in small circular motions.

LAY DOWN THE BASE COLOR

Sketch out the drawing and ink it with a black fine-line pen. Use Copic markers to fill in the base colors. Use E33 for the skin, RV10 for the pink areas, E74 for the hair, B93 for the blues and Y11 for the yellows. At this point, it doesn't matter if the colors look patchy because they will be blended out later.

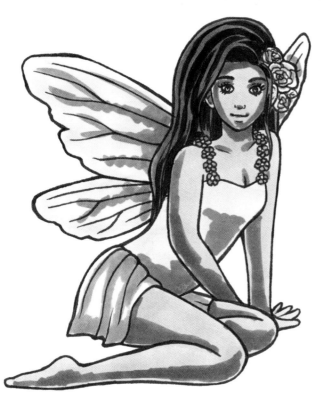

2 ADD THE DARKEST SHADOWS

Use Copics and small circular motions to color in the deepest shadows. Use E37 for the skin, 100 (black) for the hair, RV34 for the pinks, Y28 for the yellows and B95 for the blue flowers. I recommend you complete this step for only one section at a time (just the skin, for example), and then move on to step 3. Once that section is fully shaded and blended, repeat steps 2 and 3 for the next section. This will help ensure the ink stays wet so colors blend better.

3 BLEND THE COLORS

Use intermediate colors and circular motions to blend out your colors. You might have to go back and forth between colors until you get a nice blend. Your darkest colors will lighten during the blending process, so you'll have to go back in and darken them. For intermediate colors, use E35 for the skin, E77 and E79 for the hair, RV11 and RV32 for the pinks and Y13 and Y23 for the yellows. Also add some yellow to the tips of the wings. To make the shadows more interesting, add B93 to the skirt and bodice and B95 to the skin. Use RV34 on the cheeks and lips.

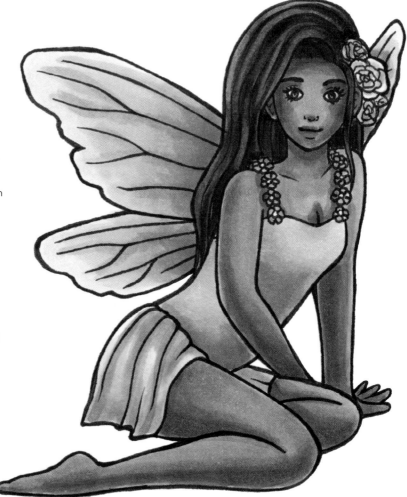

Demonstration
FEATHER BLENDING

Feather blending is useful when coloring large areas or when coloring in a long object like this character's cape.

MATERIALS

black fine-line pen
cardstock
Copic markers: R35, R46, R89, V17
eraser
HB pencil

For this technique, flick your marker upward to create a tapered line. This makes the line darkest and thickest at the bottom, gradually getting lighter and thinner towards the top.

1 SHADE WITH THE DARKEST COLORS

After sketching and inking your drawing, color in the bottom of the cape with Copic R89. Use upward flicking motions. At the base of the collar, flick upward onto the collar and downward onto the cape.

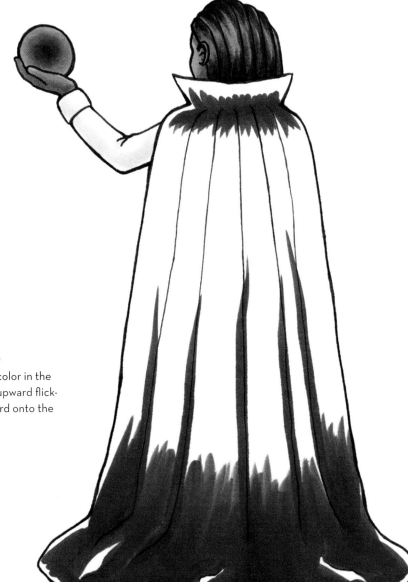

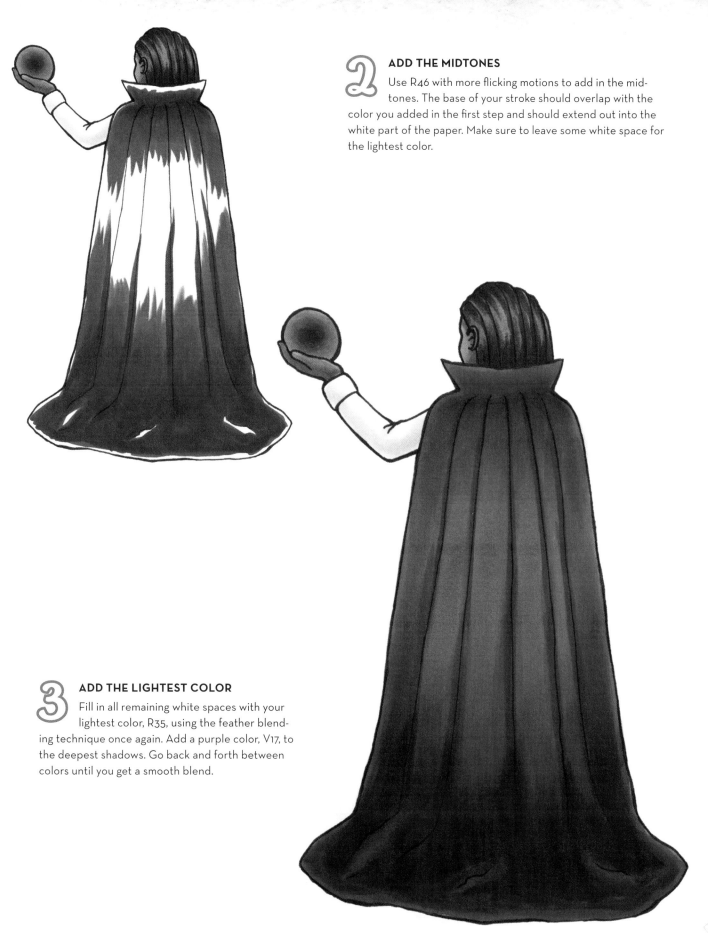

2 ADD THE MIDTONES

Use R46 with more flicking motions to add in the midtones. The base of your stroke should overlap with the color you added in the first step and should extend out into the white part of the paper. Make sure to leave some white space for the lightest color.

3 ADD THE LIGHTEST COLOR

Fill in all remaining white spaces with your lightest color, R35, using the feather blending technique once again. Add a purple color, V17, to the deepest shadows. Go back and forth between colors until you get a smooth blend.

TiP-TO-TiP BLENDING

This technique is great for when you have two colors that don't blend well together because they're too different. It's extremely useful if your marker collection is on the smaller side.

MATERIALS

cardstock

**two brush markers:
one light color, one
dark color**

1 TOUCH TIPS
Take the two colors you want to blend and use the lighter color to dab the tip of the darker color. Some of the darker ink will transfer onto the lighter marker.

2 START BLENDING
Quickly start blending out your colors using the lighter marker. The color will gradually lighten until it's back to its original color.

3 REPEAT
Once the color is back to normal, dab the darker nib again and continue blending as needed.

Demonstration
STIPPLING

Stippling is when you color in an area using a bunch of small dots. This technique can be used with almost any medium and is a great way to add texture.

MATERIALS

brush markers or watercolor paints and paintbrush

cardstock or watercolor paper

1 LAY THE BASE COLOR
Choose a base color and fill in the entire area.

2 START STIPPLING
Using the same color, dab your marker or paintbrush onto the paper. Concentrate your dots in areas that need more shading.

3 ADD MORE SHADING
Use one or more darker colors to add more shading using the same stippling technique.

Colorless Blender

Colorless blender solution is another option for blending when working with alcohol-based markers. It is a plain, clear ink solution with no dye added. It comes in marker and liquid form. The liquid can be applied with a paintbrush or a cotton swab. Rubbing alcohol is a cheaper alternative that is just as effective.

Here are some ways you can use it in your art.

BLENDING TO WHITE

Colorless blender allows you to blend a pale color into white, assuming you're using white paper. In this image, the skin tone is very fair, so I used colorless blender to make sure the lightest areas stayed white.

FIXING MISTAKES

If you accidentally color outside the lines, colorless blender can be used to push the ink back inside the lines. In this scenario it's best to use a colorless blender marker to get more precision than you would with a cotton swab. You can also apply more pressure compared to a paintbrush. It's difficult to completely get rid of the mistake, especially if the color is dark, but it still helps a lot. It will be easier to fix if the ink is still wet.

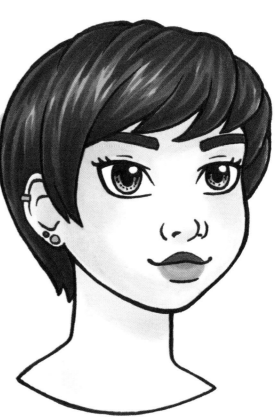

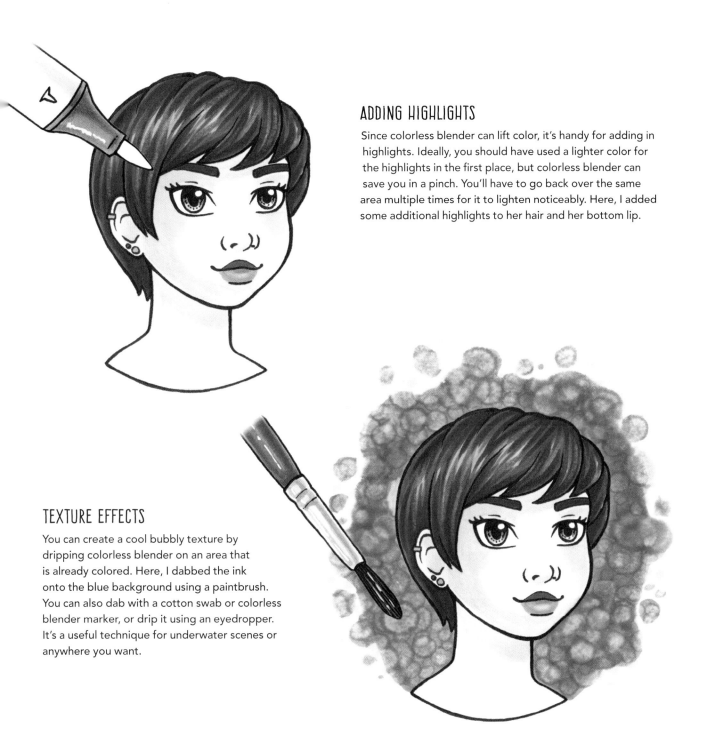

ADDING HIGHLIGHTS

Since colorless blender can lift color, it's handy for adding in highlights. Ideally, you should have used a lighter color for the highlights in the first place, but colorless blender can save you in a pinch. You'll have to go back over the same area multiple times for it to lighten noticeably. Here, I added some additional highlights to her hair and her bottom lip.

TEXTURE EFFECTS

You can create a cool bubbly texture by dripping colorless blender on an area that is already colored. Here, I dabbed the ink onto the blue background using a paintbrush. You can also dab with a cotton swab or colorless blender marker, or drip it using an eyedropper. It's a useful technique for underwater scenes or anywhere you want.

CLEANING SURFACES

If you've worked with markers for a while, you know they are difficult to clean off surfaces like your desk. Marker ink always ends up on the barrels of other markers as well. Water doesn't do the trick, so the best way is to clean it up with the colorless blender solution. You can use a colorless blender marker, or put some rubbing alcohol in a small container and use a cotton ball or cotton swab. It makes cleanup a breeze, and your markers will look like new.

Ink Dripping

Bottles of refill ink can be purchased for some marker brands, and you can use this ink to create dripping effects. Alternatively, you can use a marker and color in a circle repeatedly until a lot of ink comes out.

DRIPS ON DARK INK

Here I dripped ink directly out of the bottle onto a dark background. It adds an interesting texture, especially when drops overlap. For best results, wait until a drop of ink is almost dry before overlapping another; otherwise they'll fully bleed into one another.

FLIP THE PAGE OVER

This is what the same image looks like on the reverse side of the cardstock. The drops of ink soaked all the way through, creating a really nice texture. You can drip ink on one side of the paper and complete your illustration on the other side.

DRIPS ON LIGHT INK

Here's a small example of dripping ink onto a lighter background. The drops look more vibrant, but the overall effect is less interesting compared to light ink on a dark background.

USING MARKERS

In this image, markers were used instead of drops of ink. It creates a similar look but the edges of the circles aren't as dark. You have to color the same area over and over to get the background to lighten.

Salt With Watercolor

A really fun way to add texture to watercolor is to sprinkle some salt into the paint while it's still wet. The salt pushes away pigment, leaving white splotches underneath.

RESULTS VARY

Part of the fun is the unpredictability of the salt pattern. The way the salt reacts depends on how wet the paint is, how pigmented the paint is, how much salt you add and how coarse the salt is. Finer grains of salt make smaller splotches than coarse salt, so try playing around with both table salt and kosher salt. If the paint is too dry or there isn't enough pigment, the effect may not work.

PRACTICAL USES

This texture can be added to almost anything. It works great in skies, trees, water or anywhere that feels a little too plain. You can even use it on clothes. This little girl's dress looks shimmery because of the salt texture. Simply sprinkle on the salt while the paint is still wet, let the paint dry completely, then wipe away the salt.

MASKING FLUID

MATERIALS

masking fluid
paintbrush
watercolor paints
watercolor paper

Masking fluid, also known as liquid frisket, is a medium applied onto your art to protect the paper from any paint you apply on top. It's used to keep certain areas of the paper white by preventing paint from touching the paper. It's made of latex and can be removed by peeling it off. Masking fluid comes in squeezable tubes with a fine tip applicator, as well as bottles, which require a paintbrush for application. Masking doesn't work well with markers because the ink absorbs into the paper and seeps under the latex. Masking is best suited for watercolors or airbrushing because the paint sits on the surface of the paper and doesn't get under the latex.

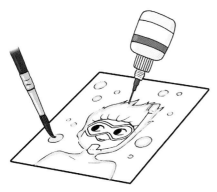

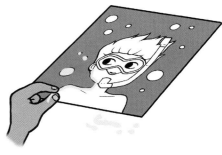

1 APPLY THE MASKING FLUID

Decide which areas need to be masked. In this case I wanted to protect the boy and the bubbles surrounding him so I could freely paint the background.

Apply masking fluid inside the areas you want to protect using a paintbrush. You don't need to fill in the entire area—just along the edges.

2 PAINT THE BACKGROUND

Once the masking fluid is dry, paint in the desired areas. The masking fluid will act as a barrier, preventing the paint from seeping outside the protected area.

3 REMOVE THE MASKING FLUID

After the paint is dry, the masking fluid can be removed by peeling or rubbing. Peeling works best when there's a thick layer of latex, and rubbing it off works well in areas where the latex is thinner.

4 COMPLETE THE PAINTING

Finish the painting by coloring in the remaining areas.

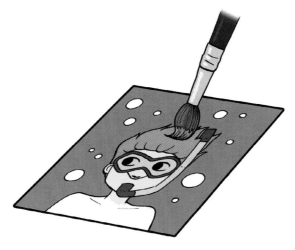

Demonstration
MASKING FILM

Masking film is used for the same purpose as masking fluid, but it comes in the form of a clear plastic sheet with an adhesive backside—kind of like a big sticker. It can easily cover large areas, making it well suited for airbrushing, paint splattering or any other messy technique. You'll also get straighter edges and sharper corners than you would with masking fluid. Pieces of masking film can be saved and reused for future projects.

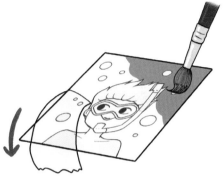

MATERIALS

craft knife
masking film
paintbrush
watercolor paints
watercolor paper

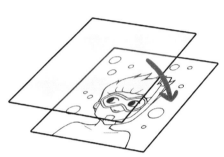

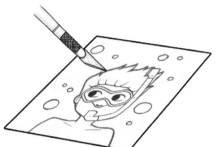

1 APPLY THE MASKING FILM
Trim the masking sheet to the size you need, then remove the backing and stick it down onto your art. Press down firmly to remove any air bubbles.

2 CUT THE MASKING FILM
Using a craft knife, carefully cut the masking film along the outlines of the character and the bubbles. You need to press hard enough to cut through the film, but be careful not to cut into your paper. Getting the right amount of pressure takes practice.

3 REMOVE THE FILM FROM THE BACKGROUND AND PAINT IT
Slowly peel away the masking film that's covering the background. Save it so you can reuse it for another drawing. Then paint in the background.

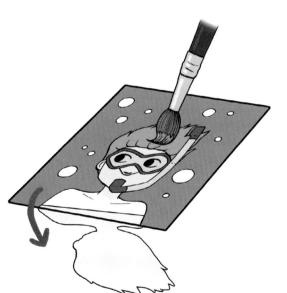

4 REMOVE THE REMAINING FILM AND FINISH THE PAINTING
Once the background is dry, gently remove the rest of the masking film. Finish the painting by coloring in the character and the bubbles.

Combining Mediums

Using more than one medium in a single drawing is a great way to add more texture, make patterns or add highlights. Try combining watercolors, acrylics, pencils, markers and more. The best paper to use for this is bristol board or mixed-media paper since they're designed to work well with many mediums.

COLORED PENCIL ON WATERCOLOR

Here is a base of light green watercolor with blue and green colored pencil on top. Colored pencils are good for adding shading, texture and fine details.

COLORED PENCIL ON MARKER

Colored pencil also layers nicely on markers. It works much the same way as on watercolor. Since marker ink is very smooth, colored pencils are a great way to add texture or to draw in a small pattern.

MARKER ON WATERCOLOR

Watercolors can make a great base for markers. The paint can be used to quickly color in large areas, and details can be added on top with markers. This makes watercolors especially convenient for backgrounds on marker illustrations.

ACRYLIC ON ANYTHING

Acrylic paints are opaque, so they can be layered on almost any medium. In this example, the base pink color was done in marker, and the pattern was done in acrylic paint. Acrylics are very useful for adding highlights and making patterns, like polka dots and plaid.

Tip

Play around with your materials to see which ones can be combined or layered to create interesting effects!

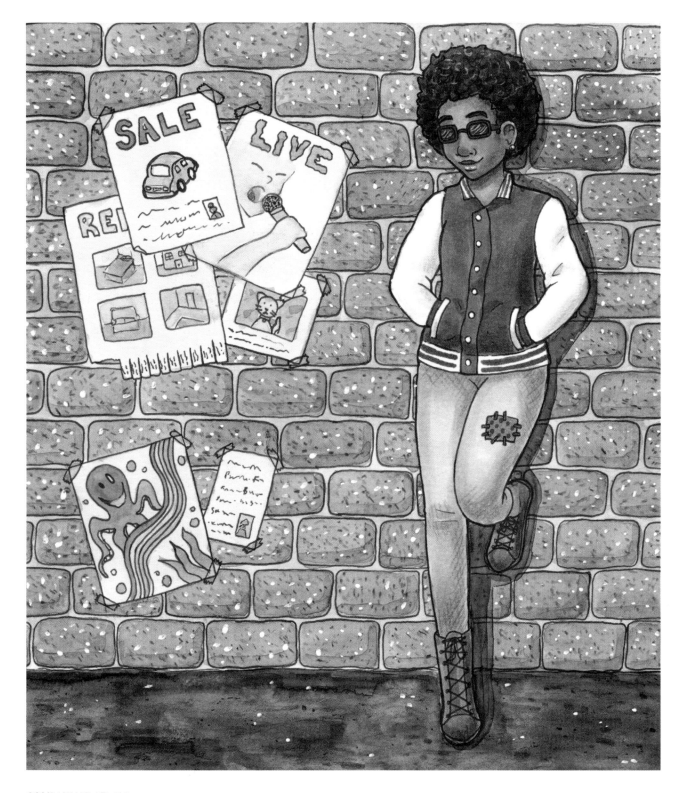

COMBINING IT ALL

This image was created using watercolors, acrylics, markers and colored pencil. The background is mostly watercolor with speckle detailing added in, using brown and gray colored pencils and white acrylic paint. The character was mainly colored with markers, then some texture was added to the pants, boots and hair with colored pencil. I also used colored pencil to add pink to her lips, cheeks and nose. Finally, I used white acrylic paint for the white buttons on her jacket and to add highlights to her hair, lips, earring and glasses.

Skin Colors

Here are some skin color combinations you can reference. These are just a few of the endless combinations you could create.

Tip

You don't have to limit yourself to traditional, realistic skin tones. You can give your characters any skin colors you like—even unnatural tones like purple or blue!

Copic colors used: YR0000, YR000, YR01, R01

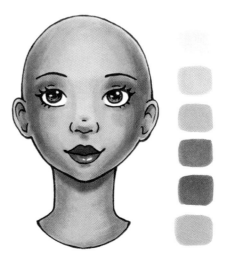

Copic colors used: YR000, E21, E53, E33, E15, R21

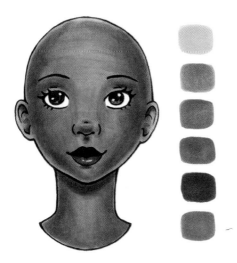

Copic colors used: E53, E33, E35, E15, E17, R85

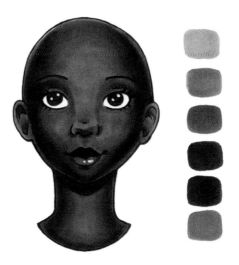

Copic colors used: E13, E15, E17, E18, E79, R85

COLORING SKIN

Learning how to color skin comes down to developing a knowledge of light and shadows. You need to know where to add shadows and where to leave highlights in order to give a face dimension. With markers and watercolors, it's best to work from light to dark because you can always add more shadows, but you can't easily bring back lighter colors.

> **MATERIALS**
>
> black fine-line pen
> cardstock
> Copic markers: E50, E51, E53, E33
> eraser
> HB pencil

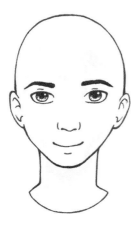

1 MAP THE SHADOWS
Use your lightest color, E50, to color in most of the face, aside from the cheeks, nose and lips. Use the same color to map out the shadows by going back over areas such as the jaw-line, eyelids, neck and under the nose. This second layer should look slightly darker than the first.

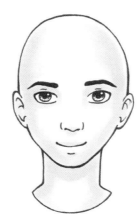

2 DARKEN THE SHADOWS
Gradually add more shading to the face using E51. Don't worry about blending at this point.

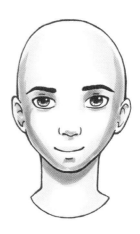

3 ADD THE DARKEST SHADOWS
Using E33, color in the deepest shadows. You still don't need to blend at this point. Each time you add darker colors, color in smaller and smaller areas so some of the previous colors are still visible. You don't want to completely cover the colors you already laid down.

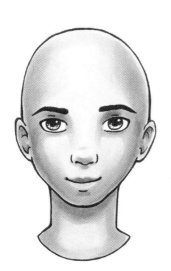

4 BLEND THE COLORS
Starting in the darkest areas, use small circular motions to blend in the shadows with E53. As you get closer to the lightest parts of the face, blend with E51 and E50.

Demonstration
COLORING HAIR

The fun part about coloring hair is giving it texture to make it look like strands of hair. The key is to create tapered strokes in the direction the hair falls. Work from light to dark, and don't overdo it by adding too many strands of hair.

> **MATERIALS**
>
> black fine-line pen
> cardstock
> **Copic markers: BV08, RV10, V01, V15, V17**
> eraser
> HB pencil

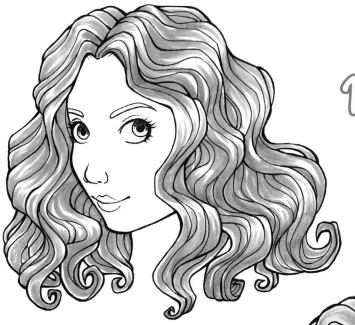

1 LAY THE BASE COLOR
Using V15 as the base color, fill in most of the hair in tapered strokes. Have the strokes follow the direction of the hair. Make sure to leave white space for the highlights.

2 COLOR IN THE HIGHLIGHTS
Use the lightest colors, RV10 and V01, to fill in the highlights. Blend these colors into the base color using the feather blending technique.

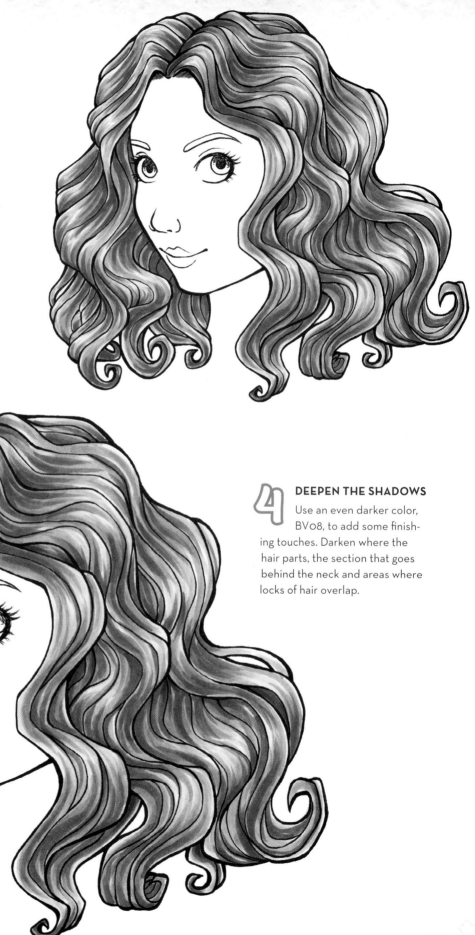

3 ADD SHADOWS

Fill in the shadows with V17, once again using tapered strokes. Blend in some areas using the base color, but leave some strokes unblended to give it the texture of hair strands.

4 DEEPEN THE SHADOWS

Use an even darker color, BV08, to add some finishing touches. Darken where the hair parts, the section that goes behind the neck and areas where locks of hair overlap.

Demonstration
COLORING EYES

Eyes are usually quite easy to color since they're often drawn so small that you don't see much detail. In those cases, the coloring can be simplified. If the eyes are more close up, you'll be able to add more detail. I usually use three colors for the eyes, and if they're drawn smaller, I'll use only two colors.

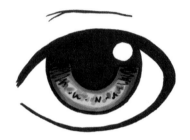

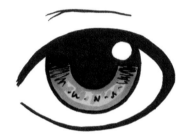

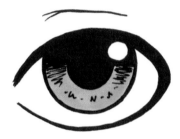

1 LAY DOWN THE LIGHTEST COLOR

Use your lightest color, B02, to color in the entire iris.

2 ADD SHADOWS

Due to the anatomy of the eye and shadows cast by eyelashes, the top of the eye is darker while the bottom of the eye is lighter. Shade in the outer edges of the iris using B05, making sure to add extra shading near the top of the eye. Use the same color to add small strokes in the lower section of the eye. This is to simulate the texture of the iris.

3 DARKEN THE SHADOWS

Use V15 to add more shading, but don't fully cover all the shadows from the previous step. I used a purple instead of a dark blue to make the eye color more interesting.

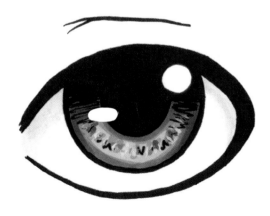

4 ADD HIGHLIGHTS

Use a white gel pen (or white gouache or acrylic paint) to add white highlights to the eye. The amount you add is up to you. Sometimes there are no highlights at all. Here there is a main circular highlight in the upper right corner, a smaller oval highlight on the left side, and small strokes along the iris. You can also add light gray shading under the upper eyelid to make the eye look less flat.

MATERIALS

black fine-line pen

cardstock

Copic markers: B02, B05, V15

eraser

HB pencil

white gel pen (or white gouache or acrylic paint)

COLORING LiPS

The main thing to remember when coloring lips is that the bottom lip is usually a lighter color because it faces upward and therefore catches light. The upper lip faces down, so it usually looks darker. This rule can be broken if there is an alternative light source, like a light from below. In most cases, though, the upper lip will be darker than the bottom lip.

> ### MATERIALS
>
> **black fine-line pen**
> **cardstock**
> **Copic markers: R20, RV32, RV34**
> **eraser**
> **HB pencil**
> **white gel pen (or white gouache or acrylic paint)**

1 COLOR THE BASIC SHAPE
Fill in the lips with your lightest color, R20. Lips don't always have an outline all the way around. In that case, carefully create the shape of the lips using your lightest color and fill it in.

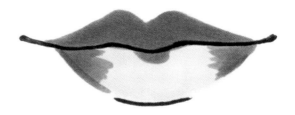

2 ADD THE SHADOWS
Use your darkest color, RV34, to fill in the upper lip completely. Add more shading in the outer corners on the lower lip and in a small section in the middle.

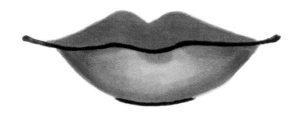

3 BLEND COLORS
With RV32 and R20, blend the colors using small circular motions. Work from the outer corners of the lips into the center.

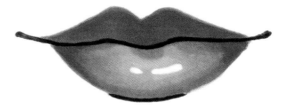

4 ADD HIGHLIGHTS
Paint in two small lines on the lower lip using a white gel pen (or white gouache or acrylic paint). They should be close to the center of the lower lip, and one line should be smaller than the other.

Demonstration
PLAID PATTERN

Plaid is a fairly simple pattern to draw, but you should follow real plaid patterns instead of randomly drawing crisscrossing lines. That way the pattern looks more authentic and believable. Another thing to keep in mind is that the pattern should wrap around the form of the body. If the lines are perfectly straight, the character will look flat.

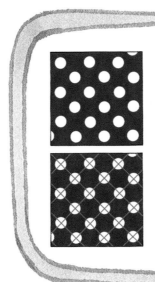

> ## MATERIALS
>
> **brush markers or watercolor paints and paintbrush**
>
> **mixed-media paper**
>
> **white gel pen (or white gouache or acrylic paint)**

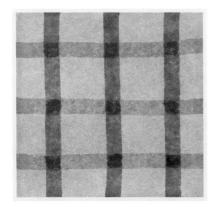

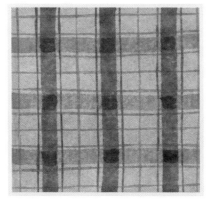

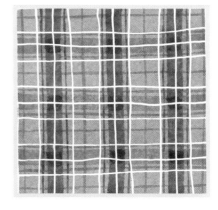

1 DRAW WIDE LINES
Once your base color is down, use a darker color to draw wide, evenly spaced lines both vertically and horizontally. Notice how the color gets darker where two lines overlap. If it doesn't look darker, color it in with a darker color. The horizontal lines don't need to be the same color as the vertical lines. Here the vertical lines are a slightly darker blue.

2 DRAW THINNER LINES
Draw thin lines on either side of the thick lines, and one more thin line halfway between the thick lines.

3 DRAW WHITE LINES
Using a white gel pen (or white gouache or acrylic paint), layer white lines down the center of each thick line. Then add one white line on each side of the thick line, farther out than the thin blue lines.

Polka Dot Pattern

Polka dots may seem simple to draw, but many people make the mistake of arranging them randomly without a pattern. That is not how they should be drawn. The example on the left shows a proper polka dot pattern. Notice how the dots are arranged in straight lines.

LACE

Lace comes in all kinds of beautiful patterns, but they're usually very intricate and daunting to draw. Here's how to break it down into simple steps.

MATERIALS

black fine-line pen or black colored pencil

cardstock or sketchbook paper

1 DRAW FLOWERS

Create evenly spaced flowers in the area you want your lace pattern. The center of the flowers should have additional detailing to fill the space. Here it looks like a flower within a flower.

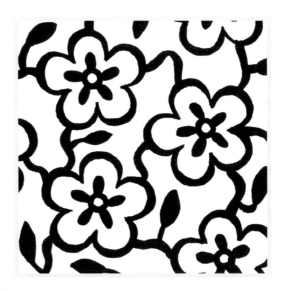

2 CONNECT THE FLOWERS

Draw stems and leaves to connect the flowers to each other. The stems should be curvy lines, not straight lines. Try to fill in as much blank space as possible.

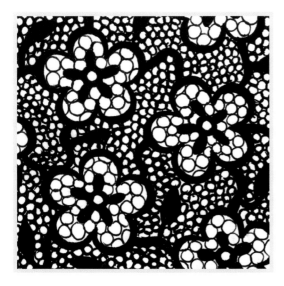

3 DRAW CIRCLES

Draw a bunch of tiny circles to fill in the remaining white space. The edges of the circles should always be touching. Use larger circles to fill in the flowers, and smaller circles to fill in the background. This will make the flowers look a lighter color than the background, which makes them stand out. This step can be very time-consuming, but it's worth the effort for such an intricate fabric.

Demonstration
WOOD & BARK

Coloring wood and bark is all about replicating their textures. You simply need to create a lot of small straight lines in the direction of the wood grain. Sometimes the grain is straight and other times it's warped and curvy. It's useful for trees, benches, tables, buildings or anything else made of wood.

MATERIALS

cardstock
Copic markers: E11, E13, E35, E57

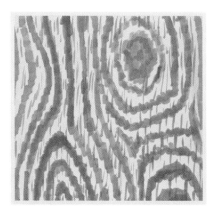

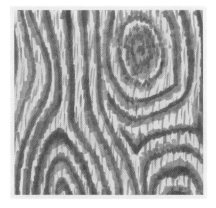

1 LAY THE BASE COLOR
Use E11 to color in the entire area. It's OK if the ink looks streaky because that adds to the look of the wood texture. Be sure the streaks go in the same direction as the wood grain. In this case, the grain runs vertically.

2 DRAW IN THE WOOD GRAIN
Use a darker color, E35, to map out the wood grain. Use a lot of vertical strokes while drawing the grain. Add smaller, tapered strokes in between the main grain lines to give it more detail.

3 DARKEN THE GRAIN
Go back over the wood grain lines with a slightly darker color, E57, using the same vertical strokes as before. You don't want to cover up your lines from the previous step, but color alongside them instead, so both colors are visible but overlapping.

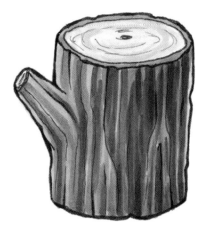

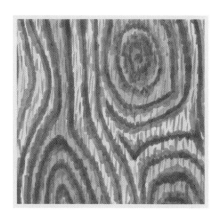

4 DARKEN MORE AREAS
Use E13, which is slightly darker than the base color, to add shading around the knots in the wood. Even if your wood grain is straight with no knots, give some areas a bit of shading anyway. Wood is often not one even color, plus some areas will look darker because of the lighting in your scene.

BARK
The same technique can be applied to bark, but use more contrast to bring out the deep ridges of the bark.

Demonstration
WATER

Water is so complex, you could have an entire book dedicated to teaching how to draw it. It looks completely different depending on the weather, its surroundings, the amount and type of motion there is, etc. Here I'll show you how to draw water that could be used for a lake or ocean scene.

MATERIALS

cardstock
colorless blender marker
Copic markers: B0000, B00, B01, B02, B04, B05, B06, B16
white gel pen (or white gouache or acrylic paint)

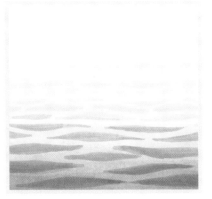

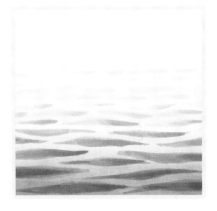

1 CREATE A GRADIENT
Water looks most blue where it's closest to the viewer, and it gradually fades to white as it reaches the horizon. Use various blues to create a gradient from blue to white. I used B05 as my darkest blue in this step.

2 DRAW SMALL WAVES
Use B06 to draw some small waves in the foreground. They should be thickest in their centers and taper at the ends. As you get closer to the horizon, gradually use lighter colors and make the lines smaller. They should also get closer and closer to one another until they're touching.

3 SHADE THE DIPS
Use slightly darker colors to shade in one side where each wave dips. Gradually use lighter colors and a colorless blender marker as you get closer to the horizon.

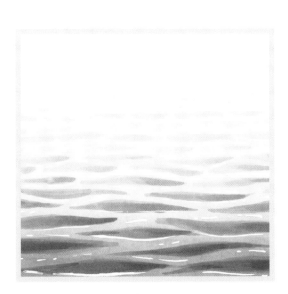

4 ADD HIGHLIGHTS
Use a white gel pen (or white gouache or acrylic paint) to add highlights to the waves. The lines should curve with the shape of the waves, and the lines should vary in length.

Demonstration
METAL

Metal is tricky to draw because it's very reflective. Not only does this create a sheen to the surface, it also causes the surface to reflect the colors of objects around it. First practice drawing the metal itself without other reflections. Once you're comfortable with that, try adding additional colors based on the environment around the metal.

MATERIALS

black fine-line pen
cardstock
Copic markers: N0, N1, N2, N4, N6

1 LIGHTEST COLOR
Use N2 to color in the cylinder, leaving three vertical lines of white uncolored. There should be a thick highlight on one side, a thinner one on the opposite side, and a thin one along the very edge of the cylinder.

2 DARKEST COLORS
Use N6 to color in a thick dark stripe in the middle of the largest light gray stripe. Leave a bit of light gray showing at the bottom. Also color in half of the top of the cylinder.

3 ADD A MIDTONE AND BLEND
Use N4 to blend the light and dark grays together using the feather blending technique. Also use N4 to blend out the top of the cylinder. Use N1 and N0 to blend the light gray into the white. All your strokes should run vertically to give the metal a bit of a streaky look.

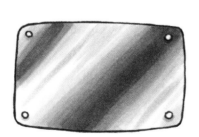

ADDITIONAL EXAMPLES
The flat sheet of metal was colored the same way the cylinder was, with a lot of straight, streaky lines. The sword has smoother shading and less contrast. Harsh lighting usually creates more contrast, while softer lighting usually creates less contrast. It's also dependent on the properties of the metal itself. Just do what you feel looks best, and don't get too hung up on the specifics of it all.

Demonstration
FEATHERS

Feathers are fun because they come in various shapes, colors and patterns, so you can create a lot of variety. As long as your strokes go in the same direction as the barbs, you can't go wrong.

1 LAY DOWN BASE COLORS
Use your lightest green, YG07, to fill in the feather entirely, making sure your strokes follow the direction of the barbs. Use B24 to color in the tip of the feather and blend it into the green using the feather blending technique.

2 ADD SHADING
Add shading to the feather using G05 and B26. You lines should be slightly curved and tapered at the ends. Give one side of the feather less shading than the other since that is the side catching more light. Make sure to shade along the stem as well.

3 MORE SHADING
Use G07 and B28 to add even more shading to the feather, using the same process as the previous step.

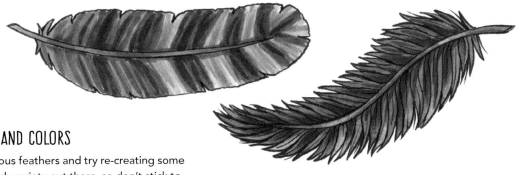

PLAY WITH SHAPES AND COLORS
Look up images of various feathers and try re-creating some of them. There's so much variety out there, so don't stick to one type of feather every time.

> MATERIALS
>
> **black fine-line pen**
> **cardstock**
> **Copic markers: B24, B26, B28, G05, G07, YG07**

CRYSTALS & GEMSTONES

Crystals and gemstones can be tricky to color because they have complex shapes and they refract light in a complicated way. It helps to look at pictures of real gemstones when trying to draw them. They can add a nice touch to your art, either as character jewelry and embellishments or as part of the scenery.

> **MATERIALS**
>
> black fine-line pen
> cardstock
> **Copic markers: B0000, B00, BV00, BV02, C5, C6, C8**
> white gel pen (or white gouache or acrylic paint)

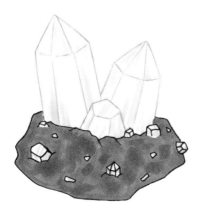
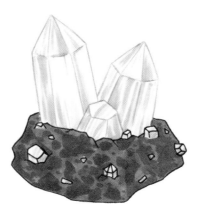
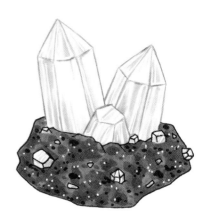

1 LAY DOWN LIGHTEST COLORS

Use B0000 and BV00 to color in the crystals. Use vertical strokes that follow the shape of the crystal. Some facets should be overall lighter than others, so be sure to leave a lot of white space and vary how much color you add to each facet. For the rocky base, use C5, but don't lay the color evenly. You want it to look patchy and rough like a rock.

2 ADD DARKER COLORS

Add more shading using darker colors. On the crystals, use B00 and BV02 to create long vertical strokes. Do not blend any of the colors together. On the rocky base, use C6 to add blotches and patches. Also add a few dots using the same color.

3 FINISHING TOUCHES

Use C8 to add speckles to the rocky base. Use a white gel pen (or white gouache or acrylic paint) to add more speckles on the rock and to add long highlights on the crystals.

GEMSTONES

Here are some examples of gemstones that could be worn by your character. Notice how each one consists of many shades of the same color, and each facet contrasts with the next. White highlights are also key to achieving a shiny look.

Demonstration
ROCKS & BRICKS

Rocks and bricks are very common in outdoor settings and architecture, so you're probably going to be drawing them a lot. The trick is to add a lot of splotches and speckles to get the right texture.

MATERIALS

black fine-line pen
cardstock
Copic markers: N1, N2, N3, N6
dark gray colored pencil
white gel pen (or white gouache or acrylic paint)

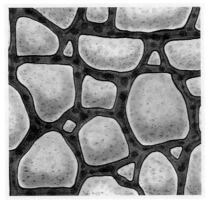

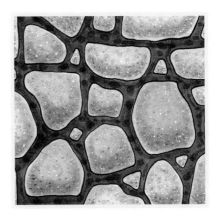

1 BASE COLORS AND SHADING

Use N6 to fill in the background. The color should look uneven and patchy. For the stones, use N1 as a base and shade with N2 and N3. The amount of blending you do will depend on how smooth you want the stones to look.

2 ADD SPECKLES

Use N2 and N3 with the stippling technique to add speckles of various sizes to the stones. Use N2 more in the lighter areas and N3 more in the shadows. Then use a dark gray colored pencil to add smaller speckles. Most of the speckles should be in the shadows.

3 ADD HIGHLIGHTS

Use a white gel pen (or white gouache or acrylic paint) to add small white speckles to the stones. Try keeping the dots random instead of evenly spaced. Consciously add small clusters of dots here and there.

BRICKS AND BOULDERS

The same technique can be used to create bricks and boulders. Boulders usually have many sharp edges and irregular shapes, which you need to keep in mind when shading.

Flowers

Flowers are commonly featured in art because they're both natural and beautiful. They also have so much diversity; you can use them over and over in your art without it being too repetitive. Many different flowers exist, even beyond the ones you commonly see in everyday life. Do some research and discover new kinds of flowers you didn't know existed. Here are some tips you can apply to any flower you draw.

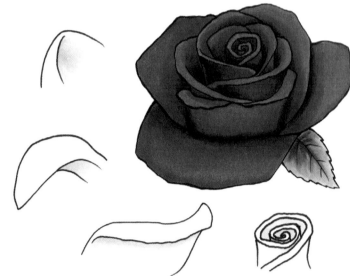

THINK IN TERMS OF 3-D SHAPES

Flowers are almost never perfectly flat. Each petal has its own curvature, and they're arranged in a specific way. These are just a few ways petals can curve, so practice these shapes. Also, notice how the petals on the rose change shape as they get closer to the center. The more you pay attention to the details of real flowers, the more accurately you can draw them.

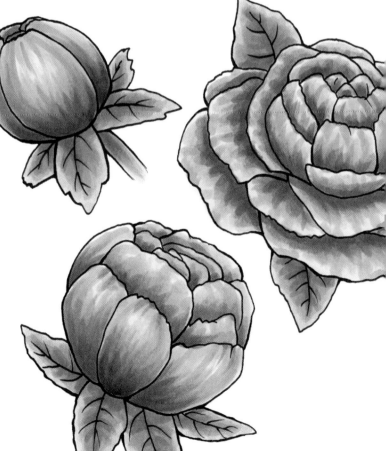

PRACTICE DIFFERENT ANGLES

It's important to practice drawing flowers from many different angles. The petals take on all new shapes when seen from another angle. Being able to draw flowers from more than one angle will add even more variety and interest to your drawings.

TRY DIFFERENT STAGES OF BLOOM

A single type of flower can look completely different depending on how much of it is blooming. The petals might be splayed out, or they might be hugging together. This is yet another way to add variation to your flowers.

Leaves

Leaves are another great element to add to your art, even if they aren't attached to trees. Just like flowers, they come in all shapes, sizes and colors. Here are some tips on how to draw them.

GET CURVY

Leaves can look static and boring when drawn perfectly straight. Add some curves to make them look more dynamic and appealing. Even if there are many small connected leaves, the stems can curve in different directions, and so can the leaves.

PLAY WITH SHAPES, COLORS AND TEXTURES

If you ask someone to draw a leaf, they usually end up drawing the same stereotypical leaf shape. Play around with different colors and textures. Some plants have colorful leaves all year-round, not just during fall. Some leaves have smooth color, some are more spotted, and some look streaky. Sometimes a single leaf is made of a few different colors. Do research on different types of leaves, and try drawing as many of them as you can.

Putting It All Together

Now that you've learned some drawing and coloring techniques, it's time to put those skills to use. I'll walk you through five full-color illustrations, step by step, so you can re-create them yourself. Feel free to change details to make the illustrations more to your taste. I mainly use markers for these drawings, but you can use whatever mediums you prefer, like colored pencils or watercolors. Now bust out those supplies, and let's get started!

Demonstration
UNDERWATER SCENE

In this demonstration, I'll show you how to create this underwater scene featuring a mermaid and some sea creatures. I recommend using markers for this scene because we'll be using the alcohol dripping technique to create a bubbly texture.

1 SKETCH AND INK THE DRAWING

Replicate the drawing as you see it here, and use a blue fine-line pen to ink the illustration. I chose blue because it's less harsh than black and matches the blues and purples of this under-water scene. If you don't have a blue fine-line pen, you can use a blue pencil instead or a regular black fine-line pen. Also, notice how many of the plants and animals are curved to face the mermaid. This is to draw the eye to the focal point of the illustration, which is the mermaid.

COLOR THE SEA FLOOR

Use shades of blue-violet to color in the sea floor. Take BV23 as your lightest color and use small, circular motions to fill in the entire area. Aim for patchy coverage instead of smooth color because you want it to have a rough, rocky texture. Then use BV29 to add your deepest shadows, which are located under and behind the shelf of rock the mermaid is sitting on, under the mermaid's fin and the area where the midground meets the background. Then use BV25 to blend the shadows into the base color, again using circular motions. Use a light blue, B02, to add patches to the sea floor. Then use your blue-violets to add more speckles and texture.

COLOR THE BACKGROUND WATER

Create a gradient of blues for the background with your darkest colors at the bottom, fading into your lightest blue at the top. Work fast and try to keep the ink wet as you go, to get the smoothest gradient possible. Gradients can be difficult to create in large areas, so don't worry about it being perfect. We'll be putting more ink on top later, which will mask some of the patchiness. I used B23 as the darkest blue, B0000 as the lightest blue, with B21 and B000 as midtones.

4 COLOR THE CREATURES AND PLANTS

Use some bright colors for the sea creatures and plants. For oranges, use YR16 and YR18 and color in the small sea horse and two of the plants. Use B01 to add some blue in the deepest shadows. Blues will help with the underwater feel of the scene and will help tie all the different colors together. For yellows, use Y04 and Y15, and B000 for blue shadows. For pink objects, use RV21, RV23 and RV25, with B00 in the shadows. For the green seaweed, create a gradient from dark to light, using BG18 as the darkest color, BG11 as the lightest color, then BG13 and BG15 as midtones. Use B01 and B23 for the blue seashell and blue plant.

5 COLOR THE SKIN

Use E23, E35 and E37 for the skin, with B02 as the deepest shadow. Use small, circular motions to get smooth ink coverage and well-blended colors. For the inside of the mouth, use RV34, and do a second layer of color on the throat to make it a bit darker than the tongue. Use R89 to draw in the shape of the lips. Don't outline all the way around the mouth. The color should stay near the center of the lips.

6 COLOR THE TAIL, FINS AND ACCESSORIES

The small fins on the mermaid's tail and the ruffles on her top are sheer, so the colors behind them show through a bit. Use light colors to partially fill in these areas, then cover the entire area with B01. The colors underneath should show through, creating the sheer, see-through look. Use V01, V12 and V25 to color in her top. Use those same colors, in addition to V15, B00 and B02 to color in the tail. Keep in mind the light source is coming from the right, so your lightest colors should also be on the right. Use these same colors once again along with V17 to add speckles all over the tail. This is a quick and easy way to get the texture of scales without drawing them all, which can sometimes look overwhelming. Use the same yellows and pinks as before to color in the rest of her accessories.

7 COLOR THE HAIR

Using RV21 and tapered strokes, fill in most of the hair, leaving some areas white for highlights. Fill in the highlights with RV10, then use RV34 and RV32 for the darkest shadows. Blend out some strokes with RV23 and RV21, making sure to leave many areas unblended to maintain the texture of hair. Most of the shadows should be located at the underside of the hair, behind the mermaid's back.

8 ADD TEXTURE WITH RUBBING ALCOHOL

This is the fun part! Use rubbing alcohol or the colorless blender solution along with a paintbrush to drip alcohol onto the drawing. Most of the drips should be on the sea floor and background, with fewer drops on the mermaid. Make some drops smaller and some drops bigger, and make some overlap each other to add depth.

9 ADD HIGHLIGHTS

Use a white gel pen or white paint to add tons of white highlights. Create irregular zigzags on the lightest areas of the hair. Also use white along some edges of the hair, tail, fins, and some plants and animals. Add highlights to the eyes, lips and accessories. Lastly, add a bunch of white dots on the mermaid and the background. The dots in the background should be smaller so they don't grab as much attention. The dots on the mermaid should vary in size and should be in groups of one, two or three. Now you're done!

Demonstration
USING MOVEMENT & LIGHT IN A SCENE

This scene features a man with some kind of magical power that creates a strong light source and causes his clothing and hair to blow around. The key is to think hard about where the light should hit versus where the shadows should be and to create smooth, flowing shapes with the clothing.

MATERIALS

black and yellow fine-line pens

cardstock

colorless blender solution (or rubbing alcohol)

Copic markers: 100, B91, B93, B95, B97, B99, C8, C9, C10, E08, E33, E42, E43, E44, E47, E50, E51, E53, G02, G05, G29, G46, Y00, Y02, Y04, Y15, Y38, YR16, YR18

eraser

HB pencil

paintbrush

yellow acrylic paint or gouache

1 SKETCH AND INK THE DRAWING

Draw the man leaning forward so it looks like he's just starting an action. His hair and clothes are all swept behind him due to the force of the magic he's creating. The man should be outlined in black since the background will be quite dark, and the magic should be outlined in yellow because it's giving off light, so it has no hard edge. Once it's colored, the yellow lines will barely be visible.

2 CREATE A GRADIENT IN THE BACKGROUND

For the background, use 100 (black), C10, C9, C8, B99 and B97 in that order to create a gradient from dark to light, starting at the top of the page. Since there's such a large area to fill in, use horizontal strokes to make it easier to blend the colors together. The streaks will show, but that's fine because it adds to the motion of the drawing, plus a lot of it will be covered in the next step.

3 ADD TEXTURE WITH RUBBING ALCOHOL

Use rubbing alcohol or colorless blender solution with a paintbrush to drip alcohol onto the background. Create various sizes of drops, and let some of them bleed into each other to create larger blobs. Let it dry, then add more drops on top.

4 COLOR THE PLATFORM

Color the platform in orange, using blues in the shadows. Use Y38, YR18 and E08 for the oranges and B93 and B95 for the blues.

5 COLOR THE REMAINING ORANGES

Use the same colors as the last step along with Y15 and YR16 to color in the rest of the orange areas. Blues are being used for the shadows because the environment is giving off blue light, and the highlights are yellow because the magic is giving off yellow light.

6 COLOR THE DARK GREENS

Use G46, G29 and B99 to color in the dark green sections of his outfit. Add Y04 in the lightest areas for highlights. Keep the position of the magic in mind. For example, the arm that is lower has yellow light on the top, whereas the higher arm has yellow light on the underside because those areas are closer to the light. Other areas that catch a lot of yellow light are his chest and knees.

7 COLOR THE LIGHT GREENS

Repeat step 6, but with lighter greens to color in more of his outfit including his cape and boots. Use G02 and G05 as greens, with B97 in the shadows and Y04 in the highlights.

8 COLOR THE SKIN AND CAPE INTERIOR

For the skin, use E50, E51, E53 and E33 for the main colors, with Y02 as yellow highlights and B91 and B93 as blue shadows. Remember that the main light source is coming from below the face. Light hits the lower eyelids, under the brow bone and nose and on the chin. Shadows fall on the top of the forehead and nose and above the upper lip. Use these same colors for the hands and neck. For the interior of the cape, use E42, E43, E44 and E47 for your browns, with B97 as blue shadows and Y00 and Y02 as yellow light. The cape should be darkest at the top since it hugs closer to his body, but there still needs to be some yellow light since the main ball of magic is located there. There should also be a lot of yellow concentrated around the swirl of magic that wraps in front of his legs.

COLOR THE MAGIC SWIRLS

Use Y00 and Y02 to color in the edges of the magic swirls. Leave the middle of the magic pure white so it looks like a bright light. Then take some yellow acrylic paint or gouache and paint a few extra swirls of magic. Let the paint dry, and the illustration is complete!

Demonstration

COMBINING TEXTURES IN A SCENE

In this scene there are many textures to color in. There's water, rock, grass, bark, leaves, hair, clothes and more. It can look boring if everything is colored in the same way, so incorporating the texture techniques you learned earlier in the book will help make the elements in the scene pop. The little boy saw a fish come to the surface and go back underwater, so he quickly swings his net to try and catch the fish.

MATERIALS

cardstock

colored pencils

Copic markers: B0000, B000, B00, B01, B02, B04, BG11, BG13, BG15, BG18, BG34, BG90, C1, C2, C3, C5, C6, C7, C8, E09, E23, E31, E37, E41, E42, E43, E50, E51, E70, E71, E74, E77, G00, G02, R20, R24, R37, RV10, RV34, YG11, YG61, YG63, YG67

eraser

gouache or acrylic paints

paintbrush

white gel pen (or white gouache or acrylic paint)

1 SKETCH AND OUTLINE THE DRAWING

To make the textures stand out even more and to give a more natural look, the entire picture is outlined in colored pencil instead of ink. Notice how the trees and other plants all lean toward the center of the picture. That's to draw the eye to the little boy, who is the focal point of this illustration.

COLOR THE WATER

Use the water texture technique from chapter 3 to color in the pond water. Add ripples around the boy's legs and below his net. Use B0000 and B000 for the lightest areas, B00 and B01 for the midtones, then B02 and B04 for the shadows. Notice how the water is darkest in the foreground and lightest in the background.

COLOR THE GRASS AND LEAVES

Use vertical strokes and feather blending to color in the tall grass. Use YG67 and BG18 for the darkest shadows, BG13, BG15 and YG63 for the midtones and YG11 and BG11 for the highlights. For the trees, layer colors from light to dark, starting with G02 and BG13, then working your way to BG15 and BG18. Use a dabbing motion with the marker to create the texture of leaves. Most of the shadows are on the underside of the trees. Use the same colors for the bushes except BG18. This way the bushes will be slightly lighter than the trees and won't look too similar.

4 COLOR THE ROCKS

Use cool grays to color in the rocks, making sure the color is splotchy, not smooth. Use C3 and C5 as your base colors, then C6, C7 and C8 in the shadows. Go back over the lightest areas with B00 to add more color to the rocks. Because the rocks are reflecting a bit of the color of the water, add some B02 at the base of the rocks. Then use your cool grays to create speckles on the rocks. Finally, use C1 to add some gray along the edge of the water.

5 COLOR THE TREE TRUNKS AND BACKGROUND

Fill in the tree trunks with E70, and map out shadows using E71. Add more shadows using E74 and E77. The shadows should be deepest at the top of the trunks, due to the leaves casting shadows on them, and also at the bottom of the trunks since the bushes are casting shadows there. Add some BG34 to the lightest areas of the trunks. For the background, use really pale colors to draw in grass, tree trunks and more leaves. Color the whole background in BG90, then use E70 and E71 to draw in some tree trunks. They should be thinner than the trees in the midground because they're farther away. Use YG61 to draw in more tree tops and more tall grass.

6 COLOR THE ANIMALS AND REEDS

There are little critters in this scene that are interested in what the boy is doing! They're so small that you don't need to use any specific coloring technique. Use E42, E23 and E37 for the squirrel and bird's nest, with BG11 for highlights. Also use BG11 for the bird and salamander, and give the salamander some spots with E31 and E23. The reeds are a warm reddish brown, so use E09 in the shadows, then E23 and E43 for the rest.

7 COLOR IN THE BOY

The top half of the boy's shirt is red to grab your attention and draw your eye to him. Use R24 and R37 for the red part of the shirt, then E41 and C1 for the white section. For his skin, use E50 and E51, and for his pants, use E41 and E43. His net uses E31 and E23, and his hair is E71, E74 and E77. Use B000, B00 and B01 in all the shadows. Use RV34 for the inside of his mouth and RV10 for his cheeks.

8 PAINT IN MORE GRASS AND ROCKS

Because marker ink is transparent, it can be difficult to color around tons of little pieces of grass, which is why we left it until this step. Instead of coloring around grass, you can simply paint the grass in later with an opaque paint like acrylic or gouache. Add grass in the midground in front of the rocks and behind the boy. Then add in some pebbles along the shoreline using various shades of gray paint.

9 COLOR REFLECTIONS IN THE WATER

Water reflects the colors of the environment around it, so make sure the boy, the rocks and the grass are all reflected in the water. You want really pale colors so the reflections aren't too distracting. For the boy, use R20, E41 and E70. For the reflection of the rocks, use C1 and C2. Then add a bit of G00 along the far left and far right ends of the water to act as reflected grass.

10 ADD HIGHLIGHTS

The last step is to use a white gel pen or white paint to add highlights to the scene. Adding too many highlights near the edges of the drawing will draw too much attention away from the boy. Add highlights to his hair, eyes, clothes and net handle. Also color in the strings of the net in white, leaving the original brown pencil lines showing a bit. Add some long highlights to the water, and small dots on the tops of the rocks. The white highlight on dark rocks can look a little too extreme. Once it's dry, use your fingernail to scrape off some of the highlights on the rocks. They will still be visible, but they'll be less white, so they'll stand out less. And now you're done!

USING MASKING FILM & MASKING FLUID IN A SCENE

In this scene I'll demonstrate how I use masking fluid and masking film. You can choose to use only masking fluid or only masking film and it will still work. For the border you can use masking tape as an alternative. You can also choose to not use any masking at all if you don't have those materials.

1 SKETCH AND INK THE DRAWING

This drawing will have lots of bright colors, so a bold black outline will suit the cartoon look. This girl is daydreaming about all the junk food she likes to eat. After drawing this, I realized the fork and spoon were a little pointless because this is all finger food, but they still add a nice touch.

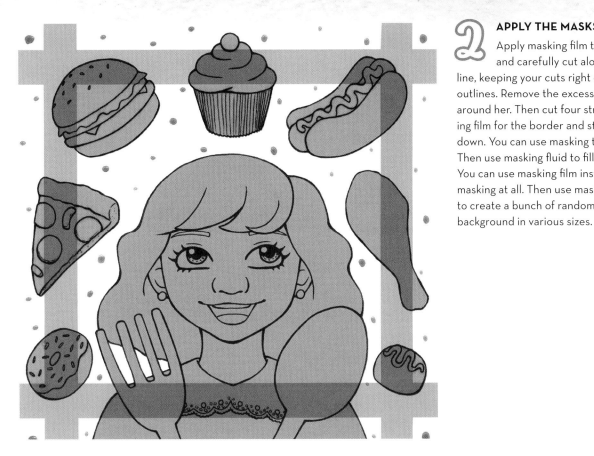

2 APPLY THE MASKS

Apply masking film to the girl and carefully cut along her outline, keeping your cuts right on her black outlines. Remove the excess film from around her. Then cut four strips of masking film for the border and stick them down. You can use masking tape instead. Then use masking fluid to fill in the food. You can use masking film instead, or no masking at all. Then use masking fluid to create a bunch of random dots in the background in various sizes.

3 PAINT THE BACKGROUND

Use blue watercolor paint and plenty of water to paint in the background. Add extra paint to some areas so the color is dark in some areas and lighter in others. While the paint is still wet, sprinkle some salt on top, preferably large coarse salt. Wait for the paint to dry completely, then remove the masking fluid and masking film.

4 COLOR THE FACE

Use B00, B02 and B05 to color in the eyes, using the darkest colors at the top of the eyes. Then use RV34 for the tongue and R85 for the throat. For the skin, use E50 and E51 as the base, and shade with E53 and E33. Use R20 and R21 to add blush to the cheeks and nose, and to color in her lips. The lip color should not go all the way around the lips. For the earrings, use R21, R22 and RV34.

5 COLOR THE HAIR

Use E74 and tapered strokes to color in the hair, leaving some space blank for highlights. Darken the hair with E77 and E79, then use E71 to blend out the highlights. The highlights are located on the crown of her head and on the tops of the waves. Shadows will be in the valleys of the waves and the area behind the neck.

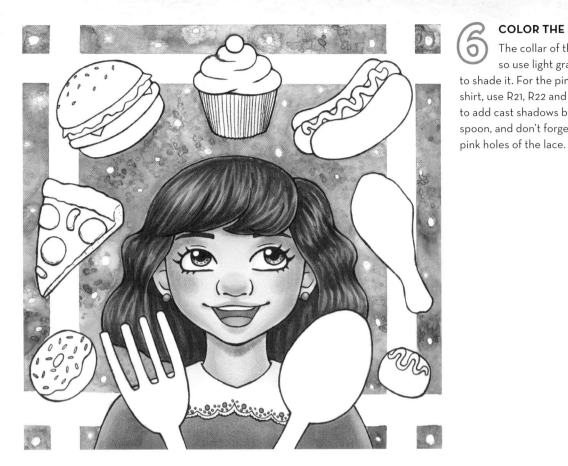

6 COLOR THE SHIRT

The collar of the shirt is white, so use light grays, W0 and W1, to shade it. For the pink section of the shirt, use R21, R22 and RV34. Make sure to add cast shadows behind the fork and spoon, and don't forget to color in the pink holes of the lace.

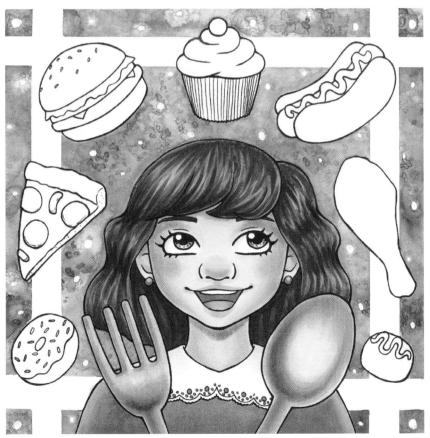

7 COLOR THE FORK AND SPOON

Use neutral grays to color in the fork and spoon. Use N0 and N1 for the lightest areas, N2 and N3 for the midtones, then N4 and N5 for the shadows. Work from dark to light, and go back and forth between colors when blending. To make them look metallic, the shadows and highlights shouldn't be overly blended, and the darkest shadows should not be right along the edges.

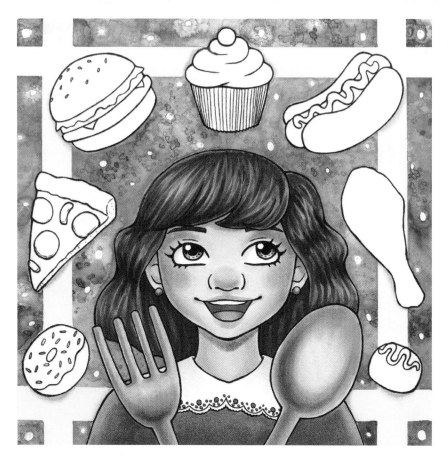

8 COLOR THE BORDER

Use a nice, bright yellow to color in the border. Use circular motions to get flat, even color with Y04, then add a bit of shading behind the food items using Y26.

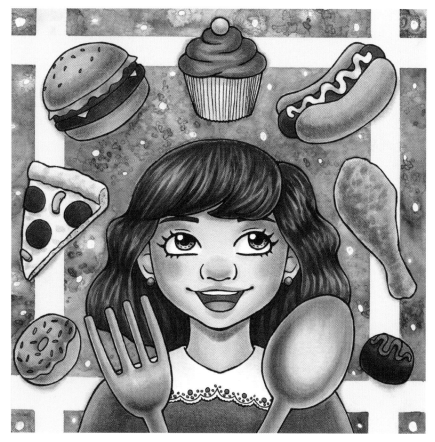

9 COLOR THE FOOD

Now it's time to color in all the yummy food! Try to reuse colors in more than one area to make the color scheme more cohesive. For example, all the pinks are the same (R21, R22, RV34), and all the yellows are the same (Y04, Y13, Y26). The dark browns are E74, E77 and E79, while the light browns are E51, E21, E31 and E33. The reddish browns (pepperoni and hot dog) are E07 and E09. The greens are G05 and G09.

10 ADD HIGHLIGHTS

Use a white gel pen or white paint to add highlights to the girl's eyes, lips and earrings. Also add highlights to the edges of the fork and spoon as well as some of the food. Use white to add sprinkles to the cupcake and donut. Finally, add more white dots to the background, making sure they're randomly spaced out, with some dots in small clusters. The drawing is now complete!

Tip

Try making the character look like you, and substitute these foods for some of your own favorites!

SCENE WITH FLOWERS & FOLIAGE

Here's a relaxing garden scene with a woman peacefully drinking tea. There's a lot of green in this picture, so it's important to get good value contrast so it doesn't all look like one giant green blob.

1 SKETCH AND INK THE DRAWING

Since the scene is so detailed, I decided to ink in various colors so the outlines wouldn't stand out too much. The woman is outlined in black so she will stand out the most. Brown outlines also would have worked well for her. I used green for all the leaves and bushes, brown for the tree trunks, and other colors that correspond to the colors of elements in the scene.

COLOR THE GRASS

Since the bushes and trees will be medium to dark greens, the grass should be a light green. Create a gradient starting dark in the foreground that gets lighter toward the background. Use YG25 for the darkest color, YG03 for the midtone and YG01 for the lightest area. Add some clusters of blades of grass with YG03 and YG25. Also use YG25 to add shadows under bushes, the birdhouse, the table and the chair. The color doesn't have to be perfectly smooth since grass itself is not smooth.

COLOR THE LEAVES

This is a big step since most of the drawing consists of leaves. The row of bushes in the middle of the drawing is the darkest so the plants don't all look the same color. It helps separate the top and bottom halves of the art. For the trees and bushes, use stippling, working from your lightest colors to the darkest ones. Since the light is coming from the upper right corner, the shadows are on the lower left corner of all the bushes and trees. For the droopy tree, use squiggly lines to get the right texture, and again build from light to dark, keeping the light source in mind. The dark bushes and plants in the foreground use G19, G29 and BG99. The lighter bushes and trees use YG03, YG06, YG09 and G19. The most distant part of the background uses G02, G00 and Y11.

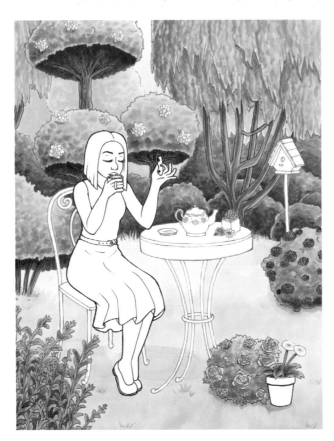

4 COLOR TREE TRUNKS AND FLOWERS

Use E71, E74 and E77 for the tree trunks, with a bit of YG03 on the side the light hits. The pink flowers use RV21 and RV25; the yellow ones use Y04, Y35 and Y38. The blue flowers use B01 and B26. All flowers have blue in the shadows, so use B01 for that. Use G02 for the green succulent on the table.

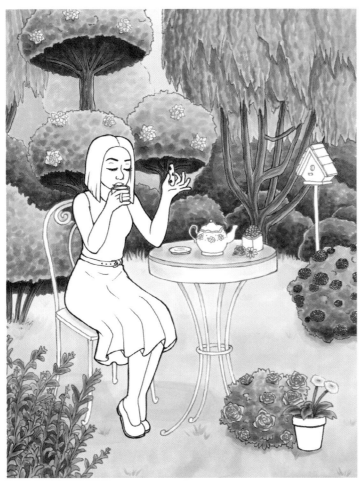

5 COLOR THE TABLE AND CHAIRS

The table and chairs are white with gray shading. Use W0, W1, W2 and W3 to shade, and add a bit of Y00 on the side the light hits. Make sure each item on the table, including her elbow, gets a shadow.

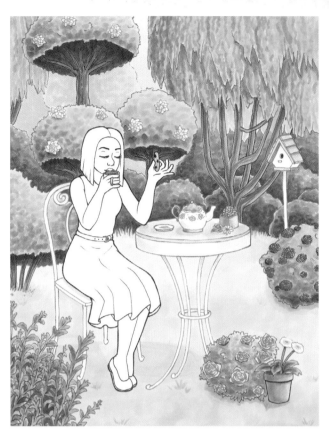

6 COLOR SMALL ITEMS

Use E42, E43 and E44 to color in the flowerpots, the cookie and the birdhouse, with a bit of Y00 in the highlights. The teacup and pot have W1 as a base shadow color, with B00 in the shadows and Y00 where the light hits. The pinks are RV21 and RV25.

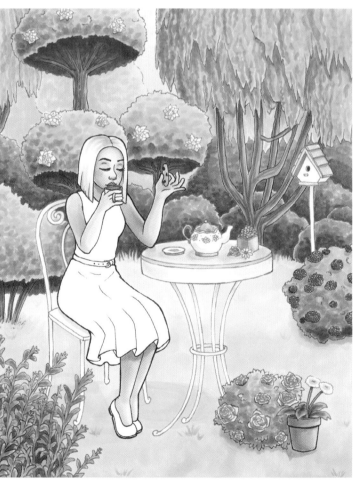

7 COLOR THE SKIN AND HAIR

For the woman's skin, use E50 for the base color, E33 for the deepest shadows and E51 and E53 to blend. Don't forget the cast shadow on her legs from the dress. Use R20 for blush on her cheeks and to give her eyelids some color. Then use R56 for the lips. For the hair, use Y11 as a base, Y28 for shadows and Y26 for blending.

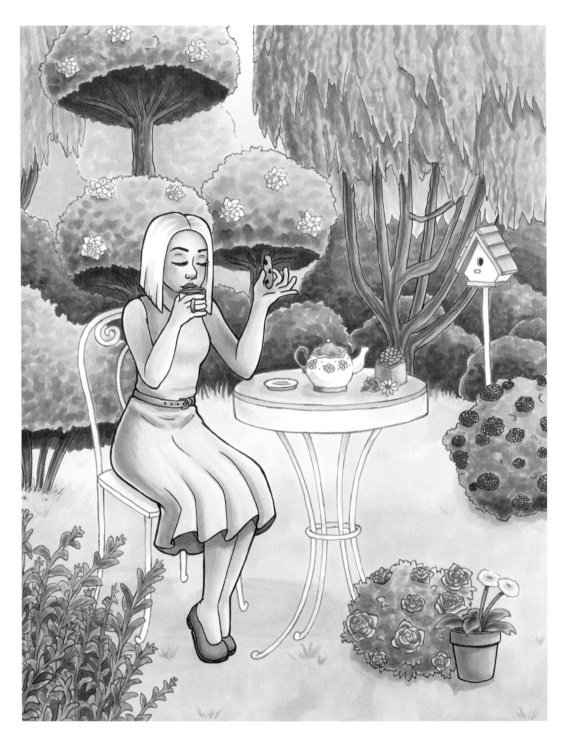

8 COLOR THE CLOTHES

Make sure the dress catches a lot of the yellow light coming into the scene. Use B01 as a base color for the dress, B02 for shadows and B00 for highlights. Then layer on Y00 in the lightest areas. Use E42 for the belt, and shade it with E44. The shoes are RV21, RV23 and RV25 with a bit of B01 in the shadows.

⑨ ADD HIGHLIGHTS

Use a white gel pen or white paint to add highlights and details to the scene. Avoid adding highlights to the leaves because it would be too distracting. Limit the white highlights to the flowers, the birdhouse, the woman and the table and chair. Add zigzag highlights in her hair, and small curved highlights to her shoes. Create a spiraled S-shape pattern on the side of the table, and add highlights to the items on the table. Add a few dots on the cookie and in the tea. Since the drawing is already really busy, less is more when adding white highlights. Once you're done with the highlights, the illustration is complete!

Conclusion

If you're anything like me, you've probably excitedly flipped through the pages of this book without actually trying any of the tutorials. Now that the excitement of seeing all the pages has worn off a bit, bust out your art supplies and start creating! You have the power to bring anything to life through your art. Will it look as good as you imagined in your head? Probably not, but that's why you need to keep trucking forward and practice. I never imagined I would be where I am today, sharing my art with the world and even making a book, which is a huge dream come true. I'm only just getting started and have a lot left to learn. If I can do it, then so can you. Anyone can draw if they put in the work, so get to work!

Baylee Jae

Index

ABOUT THE AUTHOR

Baylee Jae is a YouTuber and illustrator living in Vancouver, Canada. She has always been interested art, and after three years of studying animal sciences, she decided to follow her artistic side instead. She earned a diploma in animation art and design at the Art Institute of Vancouver, and worked as a 3D layout artist and animator before deciding to take the self-employment route. She shares her art process on her YouTube channel, Baylee Jae, where she makes all kinds of videos about art. She also has a daily vlog channel where she documents her day-to-day life as an artist, giving you an inside look at her journey. Visit Baylee Jae at her website, BayleeJae.com.

DEDICATION

Dedicated to my grandma, Sandra Connors, for being one of my first art inspirations and for always encouraging me.

Other fine IMPACT Books are available from your favorite bookstore, art supply store or online supplier. Visit our website at fwmedia.com.

21 20 19 18 5 4 3

a content + ecommerce company

DISTRIBUTED IN CANADA BY FRASER DIRECT
100 Armstrong Avenue
Georgetown, ON, Canada L7G 5S4
Tel: (905) 877-4411

DISTRIBUTED IN THE U.K. AND EUROPE
BY F&W MEDIA INTERNATIONAL, LTD
Pynes Hill Court, Pynes Hill, Rydon Lane, Exeter, EX2 5AZ,
United Kingdom
Tel: (+44) 1392 797680
Email: enquiries@fwmedia.com

ISBN 13: 978-1-4403-5056-6

Edited by Christina Richards
Production edited by Amy Jones and Jennifer Zellner
Designed by Jamie DeAnne
Production coordinated by Jennifer Bass

ACKNOWLEDGMENTS

I want to give a huge thank you to Christian for being incredibly supportive during my long work hours and late nights. You are so patient and you never complain about it. I never would have gotten in the hours required for this project if you weren't fully on board, and I'm very grateful for that. I love you!

I would also like to thank my family for giving me the opportunities in life to get to where I am today. I'm fairly certain my mom is my biggest fan because she never misses a video!

Thank you, Mona, Christina and the rest of the IMPACT team, for believing in me because I never thought I would have this type of opportunity at this point in my life, if ever.

Last but not least, thank you to all of you who have supported me on YouTube and other social media. You are directly responsible for the life I have now, and I wouldn't even have this book if it weren't for your support.

Metric Conversion Chart

TO CONVERT	TO	MULTIPLY BY
Inches	Centimeters	2.54
Centimeters	Inches	0.4
Feet	Centimeters	30.5
Centimeters	Feet	0.03
Yards	Meters	0.9
Meters	Yards	1.1

Ideas. Instruction. Inspiration.

Check out these **IMPACT** titles at impact-books.com!

These and other fine **IMPACT** products are available at your local art & craft retailer, bookstore or online supplier. Visit our website at impact-books.com.

Follow **IMPACT** for the latest news, free wallpapers, free demos and chances to win FREE BOOKS!

Follow us!

IMPACT-BOOKS.COM

- Connect with your favorite artists
- Get the latest in comic, fantasy and sci-fi art instruction, tips and techniques
- Be the first to get special deals on the products you need to improve your art